NEWCASTLE
IN THE HEADLINES

C000224879

Dave Morton

AMBERLEY

For Maria and David.

First published 2015

Amberley Publishing
The Hill, Stroud
Gloucestershire, GL5 4EP

www.amberley-books.com

British Library Cataloguing in Publication Data.
A catalogue record for this book is available from the British Library.

ISBN 978 1 4456 4778 4 (print)
ISBN 978 1 4456 4779 1 (ebook)

Typesetting and Origination by Amberley Publishing.
Printed in the UK.

About the Author

Dave Morton has worked in north-east journalism for twenty-five years. He is Nostalgia Editor for ncjMedia which incorporates the *Chronicle*Live website, and the Newcastle *Chronicle*, *Sunday Sun* and *Journal* newspapers. A history graduate with a lifelong passion for the subject, he is also a drummer, music fan, and long-suffering Newcastle United fan. And, most importantly, he is a dad…

Introduction

In the centuries to come, when we are all dead and gone, the historians of the future will have an incredibly detailed account of how we lived. Unlike any age that went before, the years of the late nineteenth, twentieth and early twenty-first centuries are recorded in all their daily minutiae. And the source of this endless information? Newspapers, of course.

Gaining huge popularity in the closing decades of the Victorian era, and enjoying a long, golden heyday as the new century roared by, newspapers delivered – as they still very much do today – a day-to-day account of the passing decades.

They informed us of what was happening in the news – both important and trivial – their adverts told us what goods and services we bought; there were sections telling us who'd been born, married, and who'd died; there was sport (especially football) and all manner of leisure activities. In the early days there were music hall and theatre listings, later came cinema and radio, and, from the 1950s, TV listings. (What time is *Match of the Day* on tonight?)

The rise of feature pages held a mirror to the fashions we wore, the cars we drove, the holidays we took, the food we ate, and even our personal problems. Who hasn't had a giggle reading the latest advice from a newspaper agony aunt? Meanwhile, readers' letters and the opinion columns gave us an insight in to the spirit and values of the day. And who hasn't inwardly groaned when, during the height of summer, the weather forecast in the paper for Saturday says it's going to bucket down with rain? All this and much more, has been captured for posterity in the form of ink on paper.

The newspaper is international, national and, of course, local. The three bestselling and most authoritative newspapers in the north east of England are based in the brilliantly historic, cultural and vibrant city of Newcastle-upon-Tyne.

The *Chronicle*, *Journal* and *Sunday Sun* for decades have been the bestselling and most trusted sources of news and information for the people of Tyneside. They saw off a host of rival local publications in the early twentiety century (the *Evening World*, the *Newcastle Courant* and more) to become the undisputed champions of the north-east newspaper world, and it is the *Chronicle* which emerged as the flagship title.

Housed, alongside the other two papers, in the city's Groat Market since 1965, and before that in Kemsley House on Westgate Road since Victorian times, the *Chronicle* has long been THE newspaper of Newcastle. Indeed, the first edition of the *Evening Chronicle* was published on Monday 2 November 1885 for the price of a halfpenny. Its front page contained dozens of small adverts for everything from dynamite, to magnetic belts that 'cured' lumbago. The paper would, of course, grow hugely in terms of journalistic sophistication and readership. And it would come to literally *Chronicle* the

life and times of this most dynamic northern city and its (for the most part) energetic and good-humoured inhabitants.

Today, the *Chronicle*, *Journal* and *Sunday Sun* are part of the Trinity Mirror group, while the hugely successful ChroniceLive.co.uk website is at the forefront of the digital news revolution and is proudly carrying the famous *Chronicle* brand into the twenty-first century, shoulder-to-shoulder with the newspaper.

Newcastle in the Headlines pays homage to the golden age of newspapers, and to a city and its people. I have raided the archives of the *Chronicle*, *Journal* and *Sunday Sun* and chosen sixty stories which attempt, in part, to illustrate the breadth of the tens of thousands of articles published across the last century and more.

I have avoided tales of murder, violence, and other unpleasant crimes which blight society, and have instead chosen stories that readers will hopefully find informative or entertaining.

We begin, aptly enough, with the death of Queen Victoria in 1901 and the reaction in Newcastle. We then travel through the decades, taking in two world wars, the opening of iconic bridges, the rise and fall of Newcastle United, heart-rending local tragedies, famous landmarks, the visits of royalty and celebrities, pioneering medicine, Geordie TV heroes and much more.

Not forgetting, that newspaper articles can also make us smile. One of my favourite stories tells of a busy Saturday in Newcastle city centre in 1954 when who should appear around the corner but, incredibly, three lumbering bears sending screaming shoppers running in all directions. It's true.

If you want to find out what happened next, read on.

Dave Morton,
July 2015

1901: Death of the Queen

A cold day in January 1901, signalled the end of the Victorian age.

For sixty-four long years the queen had ruled over a country which underwent an industrial revolution at home, and saw massive growth of the British Empire overseas. Victoria had acceded the throne in 1837 and, when the end came, she had reigned longer than most of her subjects had been alive.

Despite the frequently dreadful social conditions and inequality which Britain's rapid industrialisation had foisted on many people, there was great affection and respect for the queen. The folk of Newcastle – and beyond – were now living in a new Edwardian era.

Evening Chronicle, Wednesday 23 January 1901

Death of the Queen

Newcastle realised this morning, in common with the rest of the nation, the extent of the loss it had suffered in the death of Queen Victoria and mourned quietly, but deeply.

Few of the inhabitants had ever seen Her Majesty but all knew of her good works, and cherished towards her a feeling of love and reverence, and the news of her death, after so brief an illness, came upon them as a great shock, filling their hearts with sorrow.

The queen had reigned longer than most people had lived, and had come to be regarded almost as an institution, immovable and imperishable.

No one had any thought of death coming to Her Majesty until a few days ago, and when the end came, with dreadful suddenness, a feeling of awe overtook the people, and left them depressed.

This morning, some households and shops left their blinds drawn, and business people went to their offices with a spirit of subdued sorrow upon them.

Otherwise, matters went on very much as usual. Flags were flying half-mast everywhere, from the town hall and the Castle, from churches and chapels, from clubs and offices, from residential villas, and from all the foreign consulates in the city.

These were the chief outward manifestations of the city's sorrow. Business was conducted in the morning very much as on any other day. The board schools were open but will probably close on the day of the funeral.

At the municipal buildings, the mayor was down early, and had a consultation with the town clerk, but it was stated that there was nothing to report.

The mayor has despatched a telegram of condolence to the royal family on the preceding night, but beyond that nothing had been done.

At the local police courts, the presiding magistrates referred to the queen's death in terms of sorrow.

The Tyne Theatre will be closed this afternoon and evening, but the performances will be resumed tomorrow.

In Gateshead, profound sorrow was expressed by all classes of people.

Entertainments and other functions in the sister borough were abandoned on receipt of the news. At the parish church of St Mary's the bell was tolled.

In the mid-Tyne district, at the shipyards, works, public offices and many private houses, the Union Jack was displayed at half-mast.

On the river, vessels of all nationalities and of all sizes, from Parson's tiny Turbinia; to the big Japanese battleship at present lying at Hebburn, were flying flags in the customary way as a mark of respect to the memory of the dead sovereign.

A large number of men at Palmer's shipyard took holiday today and other establishments were similarly affected.

1905: Champions of England

On the final day of the 1904/1905 football season, Newcastle United won their first league title and first major trophy. It would mark the beginning of a glorious chapter in the Magpies' history which would earn them the nickname of the 'Edwardian masters'. They would clinch three league titles and the FA Cup before the close of 1910.

Though the names of the United stars from this long-gone age have largely slipped from living memory, players like Colin Veitch remain among the greatest ever to have worn black and white.

This was a heady but short-lived period of Tyneside football domination which, sadly, remains unparalleled to this day.

Sports reporter, John Lewis, published this piece on the day of the deciding match.

Evening Chronicle, Saturday 29 April 1905

An Appreciation of Newcastle United
A Clean Team

No matter where the League Championship goes, the Newcastle United club will have the satisfaction of knowing that in the general opinion this has been 'Newcastle's season'.

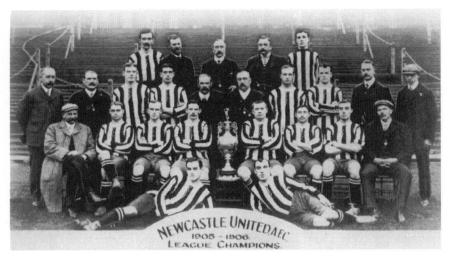

Newcastle United group shot with the First Division trophy at the start of the 1905/1906 season.

The side has played football of the clean, scientific order, and played it consistently well.

And if it failed to win the blue riband of the football field, it failed not so much because the men were at fault, as because they ran up against a style of play which nine times in ten will achieve greater results in a given time than the most scientific game ever played. With the ability to change their short-passing, three-inside game to Aston Villa's wing-to-wing crossing and dashing individualism, what a team Newcastle might become.

For years I have preached the variation of the 'scientific' with the 'individual' game, and never have my exhortations been more justified than they have been this season.

More than one professional team has, I am glad to notice, seen the mischief of a too-rigid adherence to plan, and are encouraging forwards to think for themselves at critical moments.

And if this movement is widely taken up, we may soon get back to more varied and vastly more interesting play.

I said before that Newcastle was a 'clean' team, and I am pleased to say that there has been a distinct improvement in the tone of other clubs besides United. There are fewer dirty little tricks played on opponents and a more general recognition of the possibilities of a good honest charge although, in the latter respect, the game still suffers by the rulings of weak referees.

The penalty kick has not yet quite succeeded in wiping out unfair play near the goal, but when next season this punishment becomes as real as it is apparent, I think its good effects will be strikingly seen.

1906: King Edward VII in Newcastle

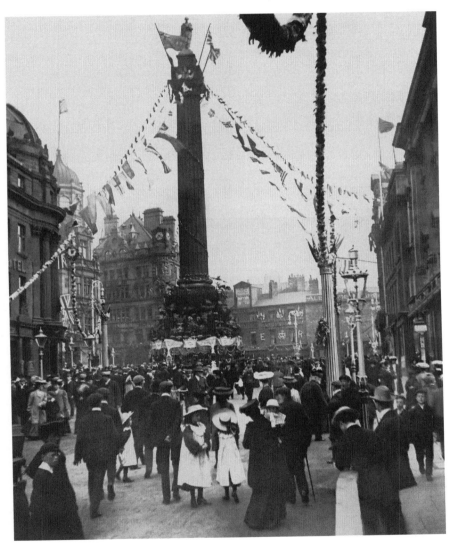

Grey's Monument is decorated for the visit of King Edward VII to Newcastle in 1906.

Of the seven magnificent bridges that today span the Tyne between Newcastle and Gateshead, the King Edward VII Bridge was the third to be opened.

It was built to take pressure off the High Level Bridge which was being used by 800 trains and light engines every day. The new bridge was officially opened by the King – before it was complete – on 10 July 1906, and finally opened for traffic on 1 October.

The following day, 11 July, saw the royal couple receive a tumultuous welcome from the people of Newcastle as thousands lined the route from the Central Station to Armstrong College (later the university) and the Royal Victoria Infirmary.

Evening Chronicle, Wednesday 11 July 1906

Visit of the King and Queen
His Majesty's Big Day and a Drenched Crowd

Today witnessed the consummation of a hope that has existed in the breasts of Novocastrians and of Tynesiders generally for a long time.

A monarch great in power and in the affection of his subjects, accompanied by his consort who has a warm place in the hearts of his people, visited Newcastle in all the ceremony of state, to perform a threefold duty associated with human kindliness, with the progress of education, and with reverence for an honoured memory.

His Majesty King Edward VII was to open the new wing of the Armstrong College, completed in memory of the late Lord Armstrong, great in science and mechanics; to open the new Royal Infirmary for the sick, lame and poor, erected at a cost of £300,000 to commemorate the Diamond Jubilee of the reign of the late Queen Victoria; and finally to unveil the marble statue of the late Queen, set up in front of the infirmary buildings by Alderman Sir Riley Lord, who was mayor in 1896 and who initiated the fund for the building of the infirmary.

It was a great day that saw this honour conferred upon Newcastle, and the people were not stinting in their expressions of joy.

The city was transformed into a summer garden, with all the colours that could delight the eye, arranged with all the cunning of the artist.

All the people of Newcastle seemed to be in the streets near the centre of the city, and the number of the inhabitants was more than doubled by the influx from the outside districts – from all the busy places roundabout, where ordinarily men toil amid smoke and the clanging of iron against iron.

High Holiday was kept. The streets were all strongly barricaded, and there were countless thousands of spectators standing behind the barriers.

By the time the king and queen went past giving, after all, but a fleeting glimpse of their presence, these people had been standing for hours – they began to assemble at three o'clock in the morning – waiting for the coming of royalty, careless of the discomfort that always accompanies such a crowd.

The route of the procession from the station to Armstrong College was as follows: Neville Street, Collingwood Street, St Nicholas Square, Mosley Street, Grey Street, Blackett Street, Northumberland Street, Barras Bridge, North Road, Park Terrace, Queen Victoria Road.

These streets were gaily decorated, and Grey Street viewed from the bottom was particularly attractive.

The weather was somewhat doubtful in the beginning, and rain began to fall before ten o'clock, and from half-past ten to half-past eleven descended very heavily, drenching the waiting thousands in the streets.

As the morning advanced, the crowd increased. Whole families came to the city – father, mother, and a retinue of children, bearing their dinners with them, and walking hand-in-hand admiringly through the streets.

Meanwhile, the king and queen who had stayed at Alnwick, left the Northumberland county town in brilliant weather. They drove to the station from the castle at a trot, and were enthusiastically cheered all the way.

The royal train arrived at the Central Station, Newcastle at 11.30 a.m.

The weather as the king and queen left the Central Station could scarcely have been worse, and the scene presented quite a contrast to the brightness of the gathering within.

The crowd was drenched but it refused to give way an inch.

At last all was in readiness for the start of the processions.

There was a cheer and a fanfare of trumpets. Cheer after cheer was heard.

The effect of the rain on the decorations was disastrous. What before had been a gay and brilliantly adorned thoroughfare was rendered hopelessly limp and bedraggled.

Just before the royal party left Grey Street and turned into Blackett Street, the proverbial dog appeared at the centre of the thoroughfare, and amid the laughter and shouts of the onlookers, dashed up Northumberland Street to escape its imaginary pursuers.

All along the route the king and queen kept bowing graciously from their covered carriage in acknowledgement of the tremendous cheering of their subjects.

As the procession reached St Thomas' Church the rain had entirely ceased, and here, for the first time, the cover of the royal carriage was let down and a great cheer welcomed the king and queen as they came into full view of the crowd.

Opposite the church was a stand whereupon 500 schoolchildren of the city had places, and as the royal carriage came to a stop opposite, hundreds of handkerchiefs waved a welcome to the occupants.

The procession halted while a verse of the National Anthem was sung, the effect of the fresh voices rang out very pleasing.

Both King and Queen appeared gratified with the singing, and the procession passed on amid a renewed fluttering of handkerchiefs.

This effusive welcome of the crowd continued till the Armstrong College was reached.

1914: The Great War Begins

On August 4 1914, Britain declared war on Germany, and the world would never be the same again. Not that the front page of the *Newcastle Evening Chronicle* reflected this.

Like other newspapers of the time, page one was often taken up with small adverts, and the news was relegated to the inside pages. Readers had to wait until page four until

they came to, in effect, one of the biggest stories of all time: the outbreak of the Great War or, as we refer to it today, the First World War.

But the cataclysmic European conflagration was on its way and Lord Kitchener's 'Your Country Needs You' appeal would soon find its way on to the front of the *Chronicle*.

Evening Chronicle, Tuesday 4 August 1914

An Alleged Spy in Newcastle Found Near Equipment Yards with Maps and Plans on his Possession

Before Newcastle Police court this morning Frederick Sukoski, aged twenty-six years and stated to be a native of East Prussia, was charged under the Official Secrets Act with obtaining information useful to the enemy and prejudicial to the interests of the state between 1 and 3 August.

The prisoner is a man of powerful build and fair complexion. Why was the case called?

The Chief Constable, Dr J. B. Wright, said, 'Yesterday information was conveyed to the police that the prisoner was found in the neighbourhood of certain naval equipment yards in the city. He was arrested with maps and plans, and other things were found in his possession. Under the circumstances I propose to ask for a remand for inquiries. I understand that the prisoner has a competent understanding of English.'

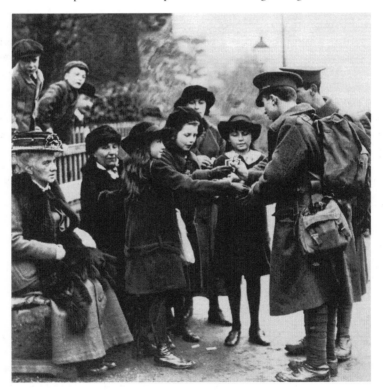

Soldiers in Newcastle receive gifts from children before leaving for the Western Front, *c.* 1914.

Detective-Superintendent Bestwick was then called and on oath said, 'About 5.45 p.m. yesterday, accompanied by Detective Gillespy, I went to the Rowton House, Pilgrim Street and there saw the prisoner. On searching him I found in his possession a map of England and Scotland, showing the distance by road, rail and air to various points. I also found on him two rules, two gauges, and also a written list of the yards on the Tyne, Wear and Hartlepools.

He stated to me that he had arrived in Newcastle on Sunday for the purposes of obtaining employment.

The chairman said, 'You will be remanded in custody for a week for inquiries. The circumstances fully justify a remand.' The prisoner, who did not speak, was removed from the dock.

Another suspected spy was arrested in Newcastle this morning in the neighbourhood of the High Level Bridge and conveyed by men of the East Yorkshire Regiment to their depot at Newcastle Central Station.

A large crowd followed but there was no demonstration. Two police officers were requisitioned, and we understand that subsequently the man was set at liberty.

Busy scenes were witnessed at the German and French consulates in Newcastle. At the German consul, men were arriving at an early hour carrying light baggage in preparation for immediate departure to their country.

As many as 200 men from Newcastle and Tyneside were sent forward from Newcastle. Large numbers of persons were attracted by the unusual scenes, and there was a crowd around the respective consulates all morning, watching the arrival and departure of the men.

Further resolutions urging the British government to keep out of the European war have been passed by local churches and other societies. But the Bishop of Durham said, 'England seems to be called upon to stand by France in this formidable crisis, by moral obligation and by the duty of national self-preservation.'

Armstrong College in Newcastle was expected to be in the hands of the military at any moment. There was a scene of activity in the departments that has not been seen in the history of the college. The college is in vacation at present. As soon as the proclamation was signed, it was stated that military beds would be dispatched to Newcastle.

Similar steps have been taken at Newcastle Infirmary where 200 beds were cleared during the weekend of medical cases that might receive treatment in their own homes.

1918: Peace

Little did they know, in the summer of 1914, that the First World War would descend into a murderous conflict which would last an agonising four years. The war would have keenly impacted on families, communities, villages, towns and cities across Britain.

When it ended in November 1918, tens of thousands from the north east were dead. Dr Martin Farr, a historian at Newcastle University, said:

> As a producer of both machines and men, no comparably-sized area in the world had greater impact on the war than Tyneside. The strong local and regional ties both encouraged those men to volunteer with their mates, and then helped their communities deal with the consequences of the war, whether they were of death, maiming, or of injuries invisible to the eye.

Evening Chronicle, Monday 11 November 1918

Rejoicing in Newcastle

Official news that the Armistice had been signed reached Newcastle this morning and was at once given to the people on Tyneside in the noon edition of the *Evening Chronicle*.

There were many people waiting outside the *Chronicle* office in anticipation of the welcome intelligence arriving and the announcement caused the most joyful satisfaction. Copies of the *Chronicle* were bought up as quickly as they could be printed. The news spread quickly to the suburbs, and in a very short while the whole town and district had been informed.

There was tremendous pressure on the local telephone service after the official message came, there being a general desire to spread the glad tidings that the hostilities had ended. The telegraph counter at the Central Post Office was also thronged with people eager to acquaint relatives and friends in the country of the good news.

There was not much cheering in the heart of the city when the message was made known, but there was much shaking of hands and other manifestations of pleasure. At many places of business, public buildings and private houses, flags were immediately displayed.

As the news became more generally known, there was increased animation in the city, and quite a festive atmosphere in the main thoroughfares. The bells of St Nicholas rang

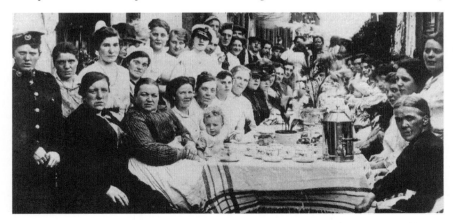

Residents of Tyneside Terrace, Elswick, Newcastle, celebrate the end of the First World War, November 1918.

out a merry peal at eleven o'clock, the hour of the ceasefire on all fronts, and at that time there was a crowd of people in the Cathedral Square.

When the news of the Armistice reached Elswick works there was a good deal of cheering among the work people, and the works and offices were afterwards closed for the day. At many other local works the employees did not return after midday and office staff had a half-holiday.

A great weight seemed to have been lifted from the public mind, and the townsfolk walked abroad light-hearted as schoolchildren, and as though they had been suddenly endowed with a new vision and joy in life.

By noon the whole city had been thoroughly 'warmed up'. The whole populace was in a state of high elation, and the fine weather and bright sunshine gave added cheerfulness to the prevailing good spirits.

Not for more than four years had there been seen so many happy faces in Newcastle as were to be noted this afternoon.

The crowds grew as the day wore on and so did the enthusiasm. Judging by the throngs in the centre of the town, some thousands of men must have taken a holiday in anticipation of the Armistice being signed.

The display of flags rapidly increased, and rosettes of red, white and blue were largely worn. The noise of maroons being fired sounded every now and then, above the pealing of the bells in the cathedral tower, and aeroplanes decorated with Union Jacks flew over the city.

Between twelve and one o'clock there was a dense crowd of excited and happy people in Cathedral Square evidently waiting for some form of civic announcement at the town hall.

The assemblage was all in good time, for it was not until three o'clock that the official announcement was made by the Lord Mayor, Mr A. Munro Sutherland, of the signing of the Armistice.

Everybody however, was in such a happy mood that waiting seemed to be of no consequence.

1919: Deadly Inferno

Built in 1912 Newcastle's Cross House was – and still is – a six-storey office block. By 1919, the basement was occupied by film distributor Famous-Lasky, who had offices and film storage vaults there.

On 23 December that year, an uncontrollable fire began in the basement. Flames shot up the stairs and the lift shaft, trapping people on the upper floors. Horrifyingly the lift shaft, and the stairs which wound round it, were the only means of escape and the city's fire brigade did not have a ladder long enough to reach the top floor.

Twelve people were killed, some by jumping from the roof.

Newcastle Journal, Wednesday 24 December 1919

Eye-Witness Accounts of the Rescue Efforts

'I was attracted to the scene, with many hundreds of gay Christmas shoppers, by the clouds of thick, throat irritating smoke, which rolled down into Grainger Street. It was pungent and smelt of celluloid.

'Overhead were faint cries, such as birds of passage make sometimes when winging their way through the night, but as Westgate Road was neared the cries developed into high-pitched screams of distress and terror. They were the screams of girls – and faces blanched.

'Westgate Road seethed with excited people whose faces were upturned towards the heights of the "flat-iron" shaped building. I pushed my way forward as far as I possibly could. The Fire Brigade had just arrived and men and women were commencing to moan and sob. Two typists had jumped from high storeys onto the pavement, one being killed instantly and the other succumbing shortly afterwards; and now the firemen's escape ladder, thrust upwards against the Fenkle Street side of the building, was yards short of the top floor, where were many girls and men.'

Jump Jump

'At almost every window of the upper storeys there were men, girls and youths crying for help and the situation looked desperate. Some of the horrified spectators lost their heads and cried "Jump, jump!" and others made megaphones of their hands and yelled "Sit still!" and "Stay there!".

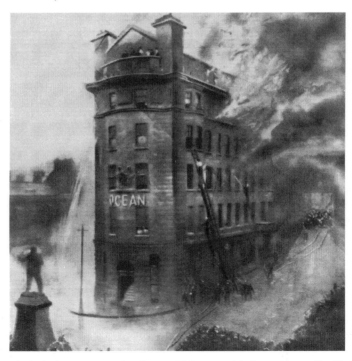

Twelve people died when a catastrophic fire engulfed Newcastle's Cross House office block in 1919.

'Two women beside me fainted, a man somewhere was moaning like a stricken beast, there were screams of terror and cries of rage from men nearby. One at my elbow kept saying thickly "Oh! God, Oh! God!" It was the only prayer he could think of and yet another swore hysterically.'

Giant Torch

'Away up yonder, eighty feet from the pavement they said it was, the cluster of girls and men looked as though they were standing on the rim of a giant torch. We prayed that they would have patience, that they would not fling themselves headlong to the pavement rather than be consumed by the devouring flames which were now within a few yards of them.

'"The firemen are getting sheets," someone shouted near the base of the building and we all cheered, yet how long it seemed before there were significant movements on the parapet. Suddenly a man shot earthwards towards the extended sheet manned by firemen, police and volunteers. There was a dull "whup" as his body struck the sheet and the crowd cheered and small boys put their fingers to their mouths and whistled shrilly. Hats and handkerchiefs were waved to encourage the girls and when one boldly took the plunge the cheering was intense."

Furnace Door

'The last girl and a man were brought down by ladder, thanks to the heroism of a fireman named Brown. While inmates of the burning building were jumping from side windows into blankets, Brown ascended the escape with a hook ladder. He entered an office window which resembled a furnace door and, amid the cheers of the crowds emerged shortly afterwards upon the parapet.

The flames were about him when he ran along the parapet, hooked the ladder onto the edge and went in pursuit of the man and girl who had scrambled to the Westgate Road side of the building. He brought them back and was so successful in reassuring the girl that she bravely swung off the parapet onto the ladder and commenced to descend.

From below a fireman on the escape grasped the bottom of the ladder, which had been swinging in the wind, and guided the girl and man to safety.

The delight of the crowd knew no bounds and rousing cheers were given the firemen who now devoted their energies to quelling the fire.'

1925: Montagu Pit Disaster

In 1925 148 men and boys were hard at work at Montagu Pit in Newcastle's West End when millions of gallons of water suddenly came crashing through the mine.

As the pitmen staggered into the light, it slowly dawned that thirty-eight of their mates had not made it from the underground tomb. For months, bodies were left in

the mine as pumps struggled to clear the water. The last corpse was not recovered until January 1926.

Mothers and wives identified their loved ones from odd buttons or distinctive sewn patches on their clothing, but a few were never able to be identified. As if by some cruel irony, the mass funerals took place in a deluge of rain.

Below are extracts from three days of newspaper coverage of the disaster.

Evening Chronicle, Tuesday 31 March 1925

Tyneside's Hour of Gloom

Dread suspense still hangs over Tyneside as the result of yesterday's flooding of the View Pit of the Montagu Colliery at Scotswood. The thirty-eight men and boys remain entombed, despite the most strenuous efforts of the rescue brigades, and with the passing of the hours, anxiety is reaching a state of feeling bordering upon despair.

The water in the pit was still rising this morning, but a huge pump is being installed with feverish haste in the hope that the trapped workers may yet be snatched from the jaws of death.

This morning the flood, in its slow but steady progress, was only some 600 yards from the shaft.

The position was summed up this morning in two ominous words: 'It's worse.'

Families waiting for news following the Montagu pit disaster, in Scotswood, Newcastle, 30 March 1925.

That was the news conveyed by one of the faithful band of miners who had remained at the pit head throughout the whole of the night in the hope that his services might be required. Although the officials are loath to abandon all hope of reaching any of the thirty-eight entombed miners, little hope can be entertained of their recovery alive, and it is now almost certain that the View Pit disaster has to be added to the toll of the mine.

Evening Chronicle, Wednesday 1 April 1925

Scotswood under the Shadow

The shadow of doom broods over Scotswood and, to a lesser degree, over Tyneside as the result of the official announcement that there is no chance that any of the thirty-eight entombed men can be rescued from the Montagu pit.

Nevertheless, hope – the most persistent of human emotions – is still cherished by relatives of the victims, and pitiful scenes were witnessed this morning at the colliery in the grey dawn.

At present, nothing can be done until the giant pump has been got into working order. This task – a hazardous one – is being pushed forward with all speed, and it was hoped this morning that the pump would be in operation by tonight.

Pitiless rain poured down on the stricken village throughout the evening, but still the crowd remained at the outskirts of the pit yard, though there was little to see, and still less to hear.

Evening Chronicle, Friday 3 April 1925

Relief Funds Reach Total of Nearly £4,000

The sun shone once again on the pit of death at Scotswood this morning.

Save for the little knots of idle miners to be seen near the pit-yard, and the notices displayed upon doors and hoardings containing the terms of the royal message of sympathy and announcing memorial services to be held on Sunday, there was very little to indicate to the casual visitor the calamity that overwhelmed the district five days ago.

The work of assembling the great pump however, was approaching completion, and it was expected that pumping operations would begin at 3 o'clock this afternoon. The water in the mine was still rising.

The relief funds are making steady progress. Up to midday the *Chronicle* appeal had brought it £2,153 11s 5d, while the Lord Mayor's fund totalled £1,762.

The *Chronicle* appeal has been answered by all classes of the community.

1928: Birth of an Icon

The Tyne Bridge is an iconic Geordie symbol, famous across the globe. With its dramatic arch rising nearly 200 feet above the Tyne, it is the main transport link between Newcastle and Gateshead, and the north and south.

Built by Teesside engineers Dorman Long and Co., the structure was designed by Mott, Hay and Anderson who based their design on the Sydney Harbour Bridge.

Staying overnight on the royal sleeper in a railway siding at Ponteland, King George V and Queen Mary travelled to Jesmond station before proceeding to open the new bridge in a horse-drawn Ascot landau.

Thousands watched the official opening in a joyous day of noisy celebration.

Evening Chronicle, Wednesday 10 October 1928

King Hopes Bridge Means Prosperity
8.00 a.m. Rush to See the King

'It is my earnest hope that this notable improvement in the facilities of transport may help to bring back to your city that full tide of prosperity which your courage and patience under recent difficulties so justly deserve.'

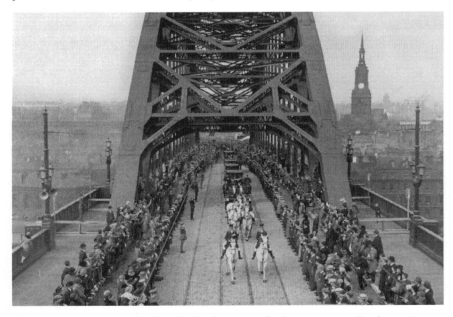

The royal procession crosses the Tyne Bridge during its official opening on 10 October 1928.

With these words the king today opened the Tyne's new wonder bridge amid scenes that provided a fitting culmination to one of the most remarkable engineering feats of the century.

The historic ceremony was made the occasion of a display of loyalty and affection for the king and his consort unprecedented on Tyneside.

An air of excitement permeated the twin boroughs at an early hour, and there were remarkable scenes long before the royal visitors were due to arrive at Jesmond Station.

Loyal enthusiasts began to assemble along the route of the procession as early as 8.00 a.m. and even at that hour thousands more were converging on points of vantage.

Tyne's Deafening Appreciation as His Majesty Turned the Golden Key

A clear expanse of blue sky was above the bridge when the king and queen drove along the approach on the Newcastle side. It was perhaps the most impressive point of the tour. The bridge was lined on both sides by veterans and ex-servicemen.

A guard of honour from the 50th Northumberland Division Royal Engineers was mounted at the entrance to the bridge, and on the Royal dais were assembled, in civic, ecclesiastical and academic robes, the chiefs of the city's life.

Cheers greeted the arrival of their Majesties who were received by the Lord Lieutenant of County Durham. The ceremonial opened with a brief service conducted by the Bishops of Newcastle and Durham, and closed with a prayer.

The Lord Mayor, inviting His Majesty to open the bridge, remarked that the development of Tyneside, by the utilisation of its natural resources, and the transformation of the river into one of the leading ports of the kingdom had called for increased transport facilities, and for forty years it had been realised that another bridge was necessary.

The king then received the gold key, but before declaring the bridge open, recalled a previous royal occasion in the city's history, when he said, 'Twenty-two years ago my dear father opened the King Edward VII Bridge. Now it is with great pleasure that I dedicate an even more imposing structure to public use. Few cities combine more favourably than Newcastle the advantages of highway, railway, river and sea transport. I congratulate you most warmly upon the bridge, constructed by the joint labours of Newcastle and Gateshead. With its wide single span and spacious approaches, the Tyne Bridge not only adds dignity and convenience to your city but also bears lasting testimony to the unrivalled capacity of British engineering trade and its workers of all grades.

'It is my earnest hope that this notable improvement in the facilities of transport may help to bring back to your city the full tide of prosperity which your courage and patience under recent difficulties so justly deserve.

'I have much pleasure in declaring the Tyne Bridge open for the use of the public.' The king's speech, delivered clearly and emphatically, was heard distinctly by all in the immediate vicinity of the royal dais. At its conclusion, His Majesty inserted the gold key into a socket which rang a bell on the bridge and raised the barrier across the centre.

The Tyne Bridge was opened. The Royal Standard was broken above the Royal stand, the Royal Artillery fired a Royal Salute of twenty-one guns. Sirens of steamers made the riverside raucous. It was a noise such as the Tyne had never before heard.

It was, too, a typical Tyneside noise, for it was started and dominated all the time by the shrill whistles from ships, workshops and factories, and the full-bodied hooting of steamer sirens. It was the famous waterway's strident announcement that a very great thing had come to pass in the life of the area.

Bells clamoured from church towers, an aeroplane flew low, and bands played. This immense clamour lasted fully ten minutes. So great was it that it caused flocks of pigeons to fly overhead, frightened and perturbed, helter-skelter in all directions. The booming of the guns died away. The shouting of the sirens ceased. The king left the royal stand and moved among the ex-servicemen of all ages, of many campaigns, who were lined up on the bridge. His Majesty conversed with limbless men, men of Mons, and with many older veterans of the regular services in 'civvies' whose coats blazed with decorations.

1929: The North East Coast Exhibition

Opened by the Prince of Wales – later Edward VIII – the North-East Coast Exhibition ran from May to October 1929, and aimed to boost the region's economy at a time of increasing hardship.

There were Egyptian-style pylons, a Palace of the Arts and a Palace of Engineering and Industry. There was also a huge boating lake spanned by a bridge. There were ten firework displays, seventy concerts, football and athletics, among a huge range of other events across the five months. The first day attracted 75,000 people and, by the time the event had finished, 4.3 million folk had visited.

The famous Exhibition beer was named after the event which took place, of course, on today's Exhibition Park.

Evening Chronicle, Tuesday 14 May 1929

Your Exhibition is a Challenge
Industry is not yet Knocked out of the Ring

There were stirring scenes in the great Exhibition Stadium this afternoon when the prince entered the royal stand to perform the opening ceremony. The luncheon party left the Festival Hall nearly twenty-nine minutes behind scheduled time, and though crowds of people waited outside in the hope of seeing the prince come out, he left quietly by another door.

As they made their way to the stadium many of the guests found the management of their silk hats a matter of anxiety in the gusty south-westerly wind that was blowing, and at least three of them had an undignified chase after their 'toppers'. The prince was

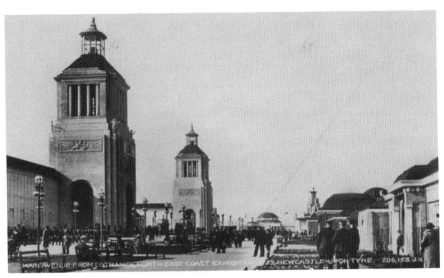

The Palace of Arts can be seen at the far end of the Main Avenue at the North East Coast Exhibition, Newcastle, in 1929.

preceded by the visiting mayors. He was greeted with cheers, waving handkerchiefs, flags and a stinging shower of cement dust which the gale had raised from the paths. When he entered the stadium there was a terrific roar of cheering.

Then the prince said, 'Forty-two years ago, almost today, a great mining, engineering and industrial exhibition was opened in Newcastle by the Duke of Cambridge, who came as the representative of Queen Victoria in the year of her first Jubilee. Today marks the inauguration on practically the same site of another and far more ambitious exhibition...

'This great town moor has been transformed to display the latest achievements of the north east coast. The general lay-out of the exhibition must command the admiration of the countless visitors from all parts of the country, which the combined effort will most certainly attract ...

'The aim of the exhibition is to revitalise existing industries – to discover how they should be adapted and, if necessary, improved...

'Of late years the world's economic development bringing intense foreign competition in its train, has weighed heavily on those basic industries on which the prosperity of this district depends ...

'Today there are certain indications to show that the industries of this district, which have had a good deal of punishment in the last few rounds, are not hit out of the ring. You are fighting back with a good northern punch ...

'This exhibition is, in fact, a challenge to the north-east coast and an announcement to the whole world that the great shop of this industrial district is still open, and its determination is to carry on. In the hope that the imagination and energy of its promoters may prove renewed prosperity to the north-east coast, I formally declare this exhibition open and wish it all possible success.'

The wind made conditions more than difficult for those on whom fell the duty of addressing so huge a gathering.

Normally, the stadium offers accommodation for about 30,000 spectators, but there must have been many thousands above that figure.

In addition, fully 10,000 people gathered on the grass around the pavilion. By reason of the conditions, the speakers standing beneath the noisily-flapping canopy had to address their words into the teeth of a gusty wind. All hope of hearing the speeches was centred in the loud-speaker installation. Initially this worked satisfactorily, the 'asides' and laugher of the pavilion party being amusingly audible.

Then the apparatus failed both the Prince and the great crowd miserably.

Opposite the north eastern loudspeaker, where an *Evening Chronicle* representative had taken up his position owing to the impossibility of penetrating the crowd, the words were distorted beyond recognition.

Obviously the Prince was reading his speech clearly. Odd words and phrases were audible, but for the most part the amplifier distorted the speaker's words into strange sounds.

The disappointment of the crowd was intense, for their interest in the opinions of the royal visitor was no less than their interest in his person.

1930: Heatwave

Many readers will remember the long, glorious summer of 1976. But what of an earlier heatwave that, by and large, will have drifted out of living memory?

The last few days of August 1930 brought extremely high temperatures to the towns and cities of Britain, including Newcastle. The *Times* reported many deaths as the mercury soared to a record high of 34.5 Celsius on 29 August. The *Chronicle* meanwhile, was noting a high demand for ice cream as Tyneside sweltered in Mediterranean conditions.

It was also reported that Geordie womenfolk had taken to wearing sleeveless dresses, while one man was even spotted outdoors in shirtsleeve order!

Evening Chronicle, Thursday 28 August 1930

Growing Toll of Deaths in Heatwave
Panting City Calls for 1,000 Gallons of Ice Cream

Hotter and hotter is the weather outlook for the next few days. The heatwave has come to stay.

'There is no sign of a break in the hot weather for days to come,' declared an Air Ministry expert today.

Newcastle, after a sweltering night, demanded ice cream with one united voice. The city's normal consumption is 150 gallons a day. The supply went up today to 1,000 gallons – and still the cry was for more.

A temperature of 93 degrees Fahrenheit (34 degrees Celsius) was recorded in Newcastle at noon – one degree higher than yesterday at the same time.

Nine deaths – one at North Shields – directly attributed to the heatwave are reported (around the country) today.

The only cooling zephyr in Newcastle today came from the flutter of the gossamer capes and sleeveless dresses – airy trifles which had been put away in the thought that they were done with for this year. 'No stockings' was reported to be the vogue in Jesmond. But this rationalisation of dress was not exclusively feminine.

The only sign of a courageous defying of male convention was the eminent city financier who drove his car down Grainger Street in his shirt sleeves.

The minimum temperature in Newcastle recorded during the night was 67 degrees (19.5 degrees Centigrade).

A normal night temperature at this time of year is 50 degrees (10 degrees Centigrade). At 2.00 p.m. in Newcastle the sun temperature was 93 degrees, the highest recorded since 1924, when records were first kept in Leazes Park.

A large thermometer in Northumberland Street registered 100 degrees at 2.45 p.m., (37.7 degrees Centigrade)

In the cafes today the menu deteriorated from porterhouse steaks to ice cream sandwiches.

Upon an ordinary summer's day, Newcastle consumes 150 gallons of ice cream. The supply has gone up today to 1,000 gallons – and still more is wanted.

The demand at the ice-house of Messrs H. S. Robinson and company in the Ouseburn is in the nature of a record. Everyone wanted more ice – hospitals, restaurants, fish shops, ice-cream manufacturers.

The output of the factory was increased to more than 50 tons today.

In spite of all that, the city could not keep cool. Swimming baths and paddling pools were invaded, and the amphibians who could not get in there crowded the trains and buses to the coast resorts in search of a cooling breeze.

The beaches at Whitley Bay and South Shields were crowded.

The BBC announces that a 'cool talk' will be broadcast in the National programme tonight at ten o'clock.

1932: FA Cup Glory

King George V and the Queen were in attendance when Newcastle United beat Arsenal 2–1 in the FA Cup final at Wembley.

The *Chronicle's* football reporter happened to be Colin Veitch, a former player from the club's golden Edwardian period, who remains an all-time United great. He wrote, 'In front of 93,000 wildly excited fans, the Arsenal began strongly and John scored in fourteen minutes. But United made a great rally, and Allen sent the big Tyneside contingent even wilder with a well-earned equaliser. Allen also scored the winning goal.'

Of equal interest were these news briefs, throwing light on the Toon Army of 1932.

Evening Chronicle, Saturday 23 April 1932

FLASHES FROM THE FINAL
Dozens of Mascots from the Final

10,000 Tynesiders, equipped with every known din-making contraption, raided London and painted the city black and white. There was a large proportion of women and girls.

A big crowd of Newcastle United supporters cheered the Queen while she was shopping at Windsor.

Rain fell heavily in London during the morning, but the weather cleared about noon, enabling the King to decide to go to Wembley, accompanied by the Queen.

There were dozens of mascots, quite small children being completely dressed in black and white.

One Newcastle supporter sang a parody of 'Blaydon Races', to 'Gannin along the Euston Road to send the Gunners to Blazes'.

Mr R. T. Hunter, a workless Hebburn man with a wife and six children, walked ten days and two nights, determined to be the first to arrive in London for the Cup Final.

In the presence of 140 members of Byker and Heaton British Legion, Sir Robert Aske, MP for Newcastle East, laid a wreath on the Cenotaph 'To the memory of the Newcastle men who died in the war'.

The railway exodus from the north east was a record for a cup final in which Newcastle United have been engaged.

Among the most entranced listeners of the broadcast of the cup final was a party of 350 blind people who attended the 'Newcastle *Chronicle*' Hall. This innovation was arranged through the Newcastle and Gateshead Home Society for Teaching the Blind. The radio arrangements were made by Mr W. Pope, secretary of Newcastle Radio Society.

Two young Newcastle supporters, who were charged at Marlborough Street, London, today with being drunk and disorderly in Hyde Park last evening, were said to have been shouting 'Up Newcastle! Up Newcastle! We have just come up to the final!' They were fined 1s each.

1935: Rail Disaster

The early decades of the twentieth century witnessed repeated horrific crashes on the railways of Britain. Health and safety, which today makes such deadly accidents relatively rare, was far from advanced or sophisticated.

In 1915, at Jarrow, a train collision and subsequent catastrophic fire killed nineteen and injured eighty-one. Thirteen years later, a head-on collision at Darlington claimed the lives of thirty-five people.

In June, 1935, the *Sunday Sun* reported that the King's Cross to Newcastle express had been involved in a midnight crash in Hertfordshire. Fourteen people, including a two-year-old child and the train's guard, James Macintosh, from Heaton died in the mangled wreckage.

Sunday Sun, 16 June 1935

TERRIBLE NEWCASTLE EXPRESS DISASTER
Northern Victims on Heavy Casualty list. Fourteen Killed and Thirty Injured – Official. Women and Babies Dead

Fourteen people were killed and eighty injured when the Kings Cross to Newcastle train crashed in 1935

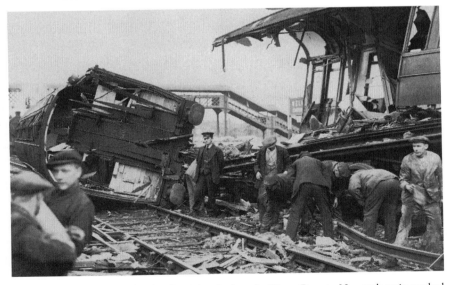

Fourteen people were killed and eighty injured when the Kings Cross to Newcastle train crashed in 1935.

One of the worst disasters on the LNER took place outside Welwyn Garden City, Hertfordshire, when the second portion of the 10.45 p.m. King's Cross to Newcastle express was wrecked in a midnight collision.

Fourteen persons were killed and thirty injured. Others received minor injuries. Most of the casualties came from the Newcastle express, many of the victims belonging to the north east coast, and during the tragic and feverish rescue work this morning, terrible and harrowing scenes were witnessed.

The Newcastle express was slowing up when out of the night, behind it, suddenly loomed the London to Leeds newspaper train at an estimated speed of 70 miles an hour.

A signalman stood helpless in his box as he saw the fast-moving parcel train smash into the Newcastle express with a shuddering crash which was heard throughout the district.

For a moment there was silence. Then the noise of escaping steam. Suddenly, fire alarm sirens shrieked through the sleeping town and people rushed to the scene from all directions.

Heroic Rescue Work

A terrible spectacle of death and disaster met the rescuers' eyes. The rearmost coach of the Newcastle train was splintered into matchwood. Another was overturned. The majority of the passengers who died were trapped in these coaches, several of the bodies being so severely crushed that identification was almost impossible.

Great were the deeds of heroism performed by these townsmen, many of whom came straight from their beds, and survivors, shaken by the collision, who rushed to their fellow passengers' assistance. Some of the first rescuers wore evening dress, having dashed from a dance on hearing the noise of the collision above the dance music.

The scene was one of carnage. Wreckage was spread over four sets of tracks, twisted metalwork hung in ribbons, escaping gas hissed over the chaos, and underneath lay the bodies of men, women and babies.

'It reminded me of wartime in France,' said an eye-witness.

Frantic Scenes

Among the dead were five women and two babies. One mother, almost demented, was found carrying her dead baby in her arms.

Soon the mud-bespattered nurses and doctors were giving first aid by the railway side, as the volunteer workers feverishly hacked away the wood and metal to free the victims. Three hours of frenzied work elapsed before the last body was taken from the wreckage. In those terrible heart-throbbing moments, dreadful scenes had been witnessed.

One man tore savagely at the wreckage.

'My mother was on the train. She may be dead,' he cried. He worked till exhaustion and strain reached their climax. Then he fell unconscious to the ground.

It was after 5.00 a.m. when the big lorry containing the dead made its last journey from the station to the little farm building which serves as a mortuary. Here, before a little altar on which stood a small wooden cross and vases of white flowers, two heroic women were preparing the dead for identification, pending to-day's streams of anxious relatives and friends.

Statement by LNER:

The following official statement was issued by the LNER shortly before one o'clock today:

The London and North Eastern Railway regrets to announce that a serious accident took place in the neighbourhood of Welwyn Garden City station at 11.30 p.m. on Saturday night. The 10.50 p.m. parcels and passenger train from King's Cross ran into the rear of the duplicate portion of the 10.45 p.m. Newcastle and West Riding express, which had been slowed down by signals at Welwyn Garden City Station.

1937: A New King is Crowned

George VI was a popular king, so much so that when his death was announced in schools and workplaces across Tyneside, on a cold February day in 1952, many tears were shed.

A shy man with a pronounced stammer, the monarchy had been forced on a reluctant Prince Albert by the abdication of his elder brother Edward VIII in 1936. In his diary, he recorded how he 'broke down and sobbed like a child'.

Nevertheless, he rose to the task and proved himself a steadfast king during the Second World War and beyond.

The day of his coronation in 1937 saw Newcastle extensively draped in flags and red, white and blue bunting.

Evening Chronicle, Wednesday May 12, 1937

NEWCASTLE REJOICES LOYALLY
Vast Crowds Watch City Ceremonies

Newcastle today joined in the national celebrations with a whole-hearted loyalty amply demonstrated by decorations which have been described as the finest in the country.

Though every town and hamlet in the north east had its own celebrations, thousands poured into the city to witness the elaborate festivities. Enormous crowds at the Town Moor watched a great military parade, in which marching troops and swooping warplanes made a thrilling spectacle.

Dull skies and a constant threat of rain failed to diminish the enthusiasm with which the north east joined in the national day of celebration.

Every town, village and hamlet had its round of coronation festivities, carefully planned for months ahead and lasting from early morning until late at night. Tens of thousands of schoolchildren lived merrily through a day, golden memories of which they will carry all their lives.

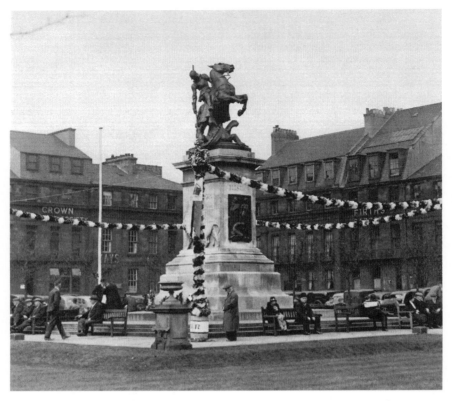

The war memorial in Eldon Square, Newcastle, in celebration of the coronation of George VI, May 1937.

Newcastle, with its £25,000 display of decorations, was the magnet which attracted thousands from outlying districts, and giant crowds assembled to watch every phase of the city's ambitious programme.

The civic service in St Nicholas' Cathedral and the brief thanksgiving services in other churches drew large congregations, thousands gathered on the Town Moor for the thrill of seeing massed troops under review, while almost every available seat was taken at St James' Park for the impressive Pageant of Youth.

Early morning streets in Newcastle wore an unusual air of gaiety. Against a background of tricolour festoons and rain freshened flowers and garlands, the scarlet coats of military bandsmen and the uniforms of khaki-clad infantry mingled with the 'Sunday best' of the thousands of Tyneside workers whom the occasion had released from duty.

Newcastle's Coronation pageantry was inaugurated this morning by a civic procession to St Nicholas' Cathedral.

Newcastle's most spectacular celebration took place on the Town Moor where more than 3,000 troops and members of ex-servicemen's organisations took part in a Coronation review witnessed by an enormous crowd. The parade, stretching across a front nearly a mile long, made a fine sight.

The full-dress uniforms of the bands of the Royal Northumberland Fusiliers, Northumberland Hussars and Royal Artillery, and the conspicuous blue of the Royal Naval Volunteer made a colourful scene on a parade decked with Union Jacks.

To the strains of regimental marches played by the bands drawn up immediately opposite the saluting base, the parade – including prancing horses – marched past General Herbert and the Deputy Lord Mayor.

Then to the strains of 'Where are the Boys of the Old Brigade' came the many ex-service organisations, and as the be-medalled veterans went past they were cheered to the echo by the vast crowd.

The mounted police bringing up the rear presented a fine sight as they went past in line.

Then came the big thrill of the march-past. Nine 'demon' fighters of No. 607 squadron of the Auxiliary Air Force, led by Squadron Leader W. Leslie Runciman, swooped down in line abreast and flashed past the saluting base at 100 feet.

It was a sight which thrilled the crowds who cheered the airmen.

The parade concluded with the Royal Salute during which 21 guns were fired, and the massed bands played the National Anthem while the Royal Standard was broken at the saluting base.

A glorious expression of loyalty and allegiance concluded with three rousing cheers for their majesties which resounded for many miles.

As the troops marched off to their various headquarters, the roads were lined with cheering crowds, who paid tribute to the fine parade they had witnessed.

800 people lifted their glasses in an impressive toast to the newly-crowned King in the Old Assembly Rooms, Newcastle, where a civic luncheon was held after the Town Moor parade.

1939: So Young, So Brave

Some of the most poignant images from twentieth-century Britain are those of children being evacuated as the gathering storm of the Second World War approached.

On 1 September 1939, the first batch of 31,222 children from Newcastle schools were evacuated. The following day, a further batch of 12,818 mothers and children under school age were evacuated.

War was declared on 3 September.

'The children are doing their part magnificently,' said an official in Newcastle, 'Children from schools in the poorer districts were thrilled by the idea of a holiday in the country.'

The youngsters boarded trains to destinations in rural Northumberland, Durham and Cumberland, amid scenes of stoicism almost unimaginable today.

Evening Chronicle, Friday 1 September 1939

BRITAIN'S BIG EXODUS OF CHILDREN BEGUN
Newcastle Children Arrive at Morpeth

Britain today began its giant four-day task of evacuating 3,000,000 children, mothers, blind and maimed – an exodus on a scale without precedent in human history.

Newcastle and Gateshead children assembled at their schools in thousands, and proceeded to the stations in an orderly manner. Most of the mothers said goodbye to their children on the doorsteps, but many went to the station to catch a glimpse of them as they arrived for their trains.

Neatly-labelled, thousands of schoolchildren left the Central Station, Newcastle, for their new homes. Treated like royalty, they were seen off by the Stationmaster and other railway officials.

No Tears

All helpers were amazed by the quiet manner in which the children assembled on the platforms to wait for their trains. There were no tears. With quiet, determined little faces, the children looked as if they fully understood the gravity of the situation.

Only a handful of parents crowded to the barrier to watch them go, and large numbers of police and special constables in the station had nothing to do but help pack the children into their carriages.

Everyone had a seat. Rucksacks were pushed on to the racks and all settled down to munch chocolate or read. One group of four boys, each about twelve years old, brought out a pack of cards and started to play.

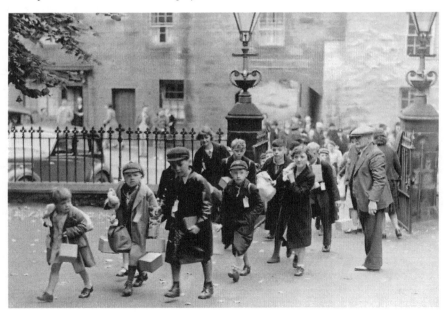

Newcastle schoolchildren arriving at Archbold Hall, Wooler, for their first meal, having been evacuated from the city in September 1939.

No Chattering

A railway official told an *Evening Chronicle* representative: 'We expected at least to hear them all chattering, but standing a yard away from any carriage it is almost impossible to hear a whisper.'

Seven hundred and fifty Royal Grammar School boys set a splendid example while waiting for their train to Penrith. They lined the platform in loose ranks of three, with gas masks slung casually over their shoulders.

Each was labelled with his name and address and the name of his school. Some had enamel mugs. When the train came in they filed in an orderly manner into the carriages.

Marching to Songs

Although the children were quiet and orderly in the station, there was some high spirits outside. One group on its way down Westgate Road marched to community singing – mostly popular dance numbers.

Trains left the Manors, Heaton, and Scotswood stations as well as the Central.

Later in the day the children became almost as excited as if they were on a school trip. Many of them, coming from poorer areas, carried all their goods in pillow cases instead of rucksacks.

Ice-cream was in great demand and the younger ones looked on the whole business as a great joke. Given buckets and spades, they would have been wild with joy.

Spirits High

By tonight, over 16,000 Gateshead children will be settled in their new 'homes' in the North Riding of Yorkshire and South Durham.

Apart from the promptness with which the children entrained (writes an *Evening Chronicle* representative), the outstanding feature of Gateshead's mass evacuation was that visits to several schools and the station failed entirely to provide me with a description of 'farewell scenes.'

Most Gateshead mothers said goodbye on the doorstep, but many went to the station and watched the young evacuees arrive from their collecting-centres.

At 6.30 a.m., in a residential section of Gateshead, I counted the first 100 children setting off for school, laden with kit. Only eleven of these were accompanied by their mothers.

Bright Send-Off

Children of all ages were setting out in groups, and their spirits were higher, if anything, than on Monday. With the kit less of a problem, thanks to lessons learned during Monday's rehearsal, parents were able to concentrate on giving their children the brightest possible 'send-off'.

The early evacuees set an example to the others by keeping rigidly to time. An example was provided at Shipcote Boys' School, which I passed two minutes after the scheduled time for departure. The school and grounds were deserted. Further on I passed the school's contingent marching cheerfully to the station.

Mothers deserve the highest praise for their restraint. Those who did take the children to school said goodbye at the gate, and teachers were never handicapped in their task of inspection and roll-call by any last-minute farewells and instructions from anxious mothers.

Comments of the mothers at the school gates were encouraging. Drops of rain fell while a mother and two daughters stood at one gate. 'It's lucky you have your macs'

the mother said. 'I shouldn't like the rain to spoil your holiday.' This was typical of the determination not to look on the black side.

Another mother, an ex-teacher due to leave tomorrow with her four year-old child, arranged to go today in order to help her former colleagues with their work.

Several children who were inadequately shod at the rehearsal were yesterday issued with sandshoes. Despite instruction, a few children turned up with bottles of water – one had lemonade – but on the whole there was little 'weeding-out' to be done in the inspection.

Orderly Scenes at Station.

The scene at Gateshead station, though continually active, had less excitement and bustle about it than any Bank Holiday.

The children were marshalled behind the bus station, near the foot of the steps leading to Gateshead West Station. Streets approaching it from the main street were closed, and police guards were posted to prevent any persons other than children and teachers from approaching.

Although many parents gathered in groups in West Street, I did not once see them trouble the police, even with requests to go and speak to the children.

Mothers Change their Minds

Today's event, changed the minds of many mothers who had not registered their children, and Gateshead evacuation offices were besieged with late-comers wishing to see their children safely away.

An official told an *Evening Chronicle* representative that today's programme worked smoothly and kept well to time.

'We are terribly busy registering mothers who are anxious to take their little children away tomorrow,' he said.

Mothers with children under five years of age are carrying out their duties well by attending the schools for the issue of tickets and instructions.

'I'll Smile'

Evacuee's Invitation to Photographer

A motor-car tour of the reception areas by an *Evening Chronicle* representative today revealed that all the children showed remarkably good spirits throughout the journey to the various places assigned to them.

'Take my photograph, I'll smile,' the cry of a pupil of St Lawrence's RC School, Newcastle, to an *Evening Chronicle* photographer on arrival at Morpeth, was typical of the spirit of the children.

Their cheerfulness was justified even more by the warm welcome which was given to them by the people who had so eagerly volunteered to make them a new 'home'.

One of the first contingents to arrive at their destination was that from St Lawrence's School, which arrived in Morpeth Station fifteen minutes ahead of time, and was taken by bus to Lynemouth and Cresswell camps.

Good Humour

Singing various popular songs, they carried out with good humour the instructions of their teachers. Mr George Barren, of Dalton Avenue, Lynemouth, chief reception officer, said that every preparation had been made to see that there was no delay in the distribution of the children to their new homes

'We arranged for Boy Scouts and older schoolchildren of Lynemouth and district to take the children to the homes allotted to them,' he said. 'We have had an amazing response throughout the district to the appeal for people to take these young evacuees, and everyone is determined to make them as happy as possible while they are here.'

Castle Ward Rural Council have appointed Mr Arthur Knox Haggle, of Hawkwell Grange, Stamfordham, as chief billeting officer for the Castle Ward Rural District.

1940: RAF Stands Firm

It was the year war came to Tyneside in the most direct and terrifying manner.

1940 – and the following year – saw a series of raids by German bombers which delivered death and destruction across the region.

In August, 1940, the *Chronicle* reported a mass air attack on Tyneside which took place in the middle of the day. A brilliant effort by RAF Spitfires and Hurricanes, and anti-aircraft guns on the ground, repelled the raiders and at least fifty-two of 150 planes were shot down.

Heroic pilots described the action, with one Hurricane squadron leader talking of a 'terrific battle' in the air.

The RAF would need to remain on hand, however, as deadly raids on Newcastle and the region continued up until the end of 1941.

Evening Chronicle, Friday 16 August 1940

NORTH EAST FIGHTERS' SMASHING VICTORY OVER NAZI MASS RAIDERS

52 of 150 Planes were Shot Down. Terrific Air Battle Ten Miles at Sea. Not one Defending Machine Lost

North east fighter pilots played a heroic part in yesterday's smashing victory of 144 German raiders down.

52 of the 150 'planes in the mass attack on the north east having been shot down without loss, it was officially revealed today.

The fighters met the raiders ten miles out at sea, where a terrific battle took place. When the raiders reached the coast they were met by a terrific barrage of anti-aircraft fire which must have come as an added shock to the already surprised raiders, who had thought to surprise us. The combination of strong ground and air attack made the raiders pay dearly.

One Northumberland fighter station distinguished itself by destroying eighteen enemy bombers and Messerschmitts.

An auxiliary Spitfire squadron in Yorkshire also shot down eight Junkers 88 Bombers.

Six of the German raiders accounted for in the north east yesterday were shot down by the anti-aircraft gunners.

As the North's bag of fifty-two does not include raiders who escaped though damaged, it is quite likely that the Nazi losses were even higher through some 'planes being unable to complete the long sea crossing home.

The total bag up to midnight of 144 German 'planes down was nearly double the RAF previous record of 78 and brought the total of German 'planes destroyed in the last five days up to 381 and the number brought down around Britain since the war began to 782.

German 'planes also attacked north-east coast areas during the night. Heavy explosions shook houses, and anti-aircraft and machine-guns were in action. One 'plane, caught in the searchlight beams, was seen to fall into the sea.

Record Day's Bag of 144

The high loss of the raiders yesterday was out of all proportion to the damage they caused. An Air Ministry communique early today stated that no serious damage was done in the raid on Croydon aerodrome. An attack on Portland was also ineffective.

150 Planes in N. E. Daylight Raid

About lunchtime the Nazis attempted an intense attack on the north-east coast. Two patrolling Spitfires and Hurricane squadrons caught the raiders before they reached the coast. The British pilots estimated that there were at least 100 bombers protected by more than fifty fighters.

These two squadrons engaged both enemy bomber and fighter formations with the result that Spitfire pilots shot down eleven of the raiders and the Hurricane pilots seven.

A twenty-three-year-old Australian pilot, in action for the second time, had a remarkable escape. 'I went up with my section to about 8,000 feet when my hydraulic pipe line burst, spraying me with oil,' he said. 'I immediately landed, jumped into another fighter and within three minutes was in the air again climbing to a height of 13,000 feet. Through the haze I saw two large formations of Heinkel 111 bombers stepped up above each other. There must have been at least thirty in each formation.

'I had to think pretty quickly. I picked out a Heinkel on the left side of the rear formation and dived down on his tail spraying it with machine-gun bullets. The Heinkel went down in flames. I then attacked a straggler. After two or three bursts of fire this bomber also burst into flames. Then across my bows flew another Heinkel. I fired two short bursts and when I last saw it smoke was coming from the fuselage.'

'Terrific Battle'

Another pilot from this Spitfire squadron, after firing a short burst at a Junkers 88, saw it explode in mid-air. The pilot believes his bullets hit the bomb rack.

An Australian pilot whose life was saved by his earphones when he was hit by a machine-gun bullet during an action in December, shot down a Junkers 88 and a Messerschmitt 110.

The squadron leader of the Hurricanes said, 'It was a terrific battle. For a while the air was filled with diving and zooming aircraft. One of my pilots blew the tail plane off a German fighter. It was just like a balloon bursting. Pieces hit my Hurricane.'

Yorkshire Attack

While this battle was in progress, another formation of about fifty Junkers 88 bombers with their usual escort of fighters approached the Yorkshire coast.

The auxiliary Spitfire squadron which shot down eight without loss to themselves were patrolling at 20,000 feet when they intercepted the enemy force. As the Spitfires attacked out of the sun, the Junkers pilots attempted to throw off their pursuers by diving into cloud.

A Toronto-born pilot in this squadron destroyed two of the eight enemy bombers. Another British fighter squadron which took part in this same action shot down five of the Junkers.

The Midlands, however, were the chief objective of the Nazi night raiders, who made further attacks early today. They were also reported at various times over North-West and South-West England and Wales

Heavy Loss, Little Damage.

Describing yesterday's raids, the Air Ministry news service stated, 'By late last night it had been confirmed that 130 Nazi raiders had been destroyed by British fighters. Eleven by AA batteries, two by infantry soldiers and one by a Lewis gun crew at a searchlight post.

'Yesterday's figure is a record for the gunners, bringing their total of enemy aircraft shot down since Sunday to thirty-three. Although RAF fighters were in the air for long periods during the day – often landing just to re-arm and refuel – reports so far show that only twenty-seven have been lost but that eight pilots are safe but wounded.'

Air Ministry Communique.

The Air Ministry communique stated, 'Further reports of enemy attacks yesterday – Thursday – evening show that little success was achieved at a high cost. In the Croydon area a number of buildings were damaged, including a scent factory, and fires were caused which were soon brought under control. On the aerodrome itself no serious damage was done, but a number of people in the neighbourhood received injuries and one death is reported.

'At Hastings, bombs fell in a residential area. One person was killed and several injured. At Rochester, industrial premises were damaged and a number of houses destroyed, but no fatal injuries are reported. Damage was done to private property at several points in Yorkshire, but only one case of fatal injury is reported from this.

'In the South West an attack on Portland was ineffective but a few casualties were caused, none of which was fatal.'

More Raids Today

Though German planes were over the north east again last night, the Midlands however, were the chief objective of the Nazi night raiders, who made further attacks early today. They were also reported at various times over North West and South West England and Wales.

Enemy 'planes were again believed to be over South-East England coast towns this morning.

Nazis Tell of North East Attacks.

German air activity today has been virtually put at a standstill by bad weather in the Channel, German sources stated in Berlin today.

A few German bombers took off this morning but returned to their bases owing to bad visibility, it was stated.

Last night, it was claimed, German bombers raided industrial armaments centres and munitions works in the Midlands and the north east of England.

All the German machines, it was stated, returned undamaged except one which entered the range of AA guns but escaped through what they described as 'clever manoeuvring'. German air activity yesterday included attacks near Middlesbrough, Newcastle and in Essex according to the German official news agency.

Several aerodromes and harbour works in these districts were bombed, says the agency.

Hangars and barracks were hit and runways destroyed.

Several British 'planes were destroyed on the ground the agency claims, and others in air battles arising out of these attacks.

The Mounting Toll.

Yesterday was the blackest day for the Nazi raiders, 144 being destroyed by midnight, nearly double the previous record.

The total of German 'planes brought down in the last five days is now 381, and the Nazis have now lost 782 'planes in and around Britain since the war started.

1941: Terror From the Skies

As an important area of heavy industry, the north east was integral in the production of ships and armaments for the war effort. German bombers were consequently quick to target the region.

Newcastle was hit hard, and there was major death and destruction wrought further afield in Jarrow, South Shields, North Shields, Sunderland, and elsewhere.

Air raids on Newcastle during the Second World War killed 141 people, and injured 587 more, with forty-seven of those deaths occurring in a major raid on Byker and Heaton on 25 April 1941.

The newspaper report on that devastating attack was at the time, as ever, circumspect so as not to give information or encouragement to the enemy.

Evening Chronicle, Saturday 26 April 1941

MAIN NAZI RAID ON NORTH EAST
Showers of Incendiaries. Newcastle Dock Hit, says Berlin

The north east suffered the main attack of Goering's bombers last night.

Though short, it was a fairly intense attack and a considerable casualty list has been reported. Berlin officials, according to the British United Press, claimed that

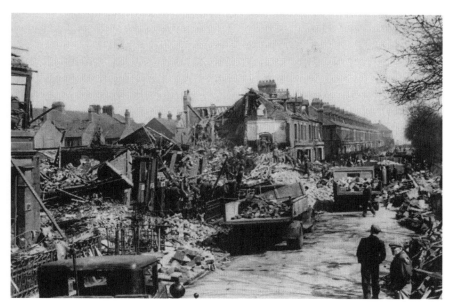

Guildford Place, Newcastle, after a devastating German air raid on 25 April 1941.

'a big attack on harbour and dock works at Newcastle was carried out by strong formations of bombers,' but later the German official news agency said it was Sunderland 'near Newcastle', which was raided.

Saying that 'bombs of all calibres were dropped in good visibility,' the agency proceeds: 'Several fires were started among the docks and shipyards where the Sunderland flying-boats are manufactured.'

Some Fatal Casualties

The Air Ministry and Ministry Of Home Security communique says: 'Enemy activity last night was mainly directed against north-east England. The attack on this area was sharp and occurred in the early part of the night, but had ended by midnight. Bombs were dropped at several points and some damage was caused. Reports show that there were a considerable number of casualties of which however, only a small number were fatal.'

Some bombs were also dropped on the East and north-east coasts of Scotland and isolated points in East and North-West England. These incidents have not caused any damage or casualties.

Incendiaries, Flares and Bombs.

The earliest North raiders dropped flares and incendiaries which lit up a wide area. Fires were promptly tackled and the worst, at a store, was well under control, before the raid ended shortly before midnight.

After the flares and incendiaries high-explosive bombs crashed down. One bomb exploded within the enclosure of a large underground public shelter where twenty people had narrow escapes.

The blast blew the shelter marshals down the steps. They recovered to find that the entrance was in danger of caving in, but they arched their backs and held the crumbling sides long enough to enable sixteen of the occupants to emerge in safety.

Four people were still in the shelter which was on the point of collapse. They waited calmly until their release through the ventilating shaft was accomplished. Shortly afterwards the roof of the shelter fell in.

Miners' cottages hit

Casualties, some of them fatal and including a mother and her eleven-year-old son, a miner, and an eighteen-year-old girl, occurred in widely-separated districts, direct hits having been scored on streets of miners' cottages.

1941: Earl Grey Loses His Head

Grey's Monument is one of Newcastle's prime landmarks. It was erected in 1838 in honour of the Alnwick-born former Prime Minster, Earl Charles Grey. The impressive structure consists of a statue of the earl standing atop a 130-feet column.

One dramatic Grey's Monument story, which today is perhaps largely forgotten, unfolded in July 1941, as the Second World War raged. Earl Grey's statue suffered a direct hit from a lightning bolt – and the head plunged on to the street below, shattering into pieces.

A decapitated Earl Grey stood forlornly atop his monument, during the war and afterwards, before finally getting a new head in 1948.

The Journal, Saturday 26 July 1941

MONUMENT HEAD CRASHES ONTO ROADWAY

Newcastle's famous Earl Grey monument, which stands at the junction of Grainger, Grey, and Blackett Streets, has been decapitated. The massive stone head fell last night on to the tram lines about 130 feet below. No vehicles were passing beneath at the time, and no one was injured.

Most of the head, part of one of the arms, and also part of Grey's cloak were dislodged, the head section weighing about two cwt. 'It smashed on impact with the roadway,' a passer-by told *The Journal*. 'One piece must have weighed a cwt, another piece could not have weighed less than six stone, and there were various small fragments.'

One of these flying fragments struck and smashed a big plate-glass window at the Monument Hotel at the top of Grainger Street. A tram however, was approaching the Monument from the Central Station, and the conductor remarked, 'We were close enough! Had we started a few seconds earlier it might have fallen on us.'

Tramway and trolley-bus overhead lines were smashed in the vicinity.

The statue on Grey's Monument was hit by lightning in 1941. The earl finally got his new head in 1948.

Two police officers, Inspector Owen and Sergeant Michael Smith, climbed the spiral staircase to the top of the monument to see if there seemed to be any danger of a further collapse.

Inspection today

They decided that the remainder of the statue appeared to be reasonably safe, but as a precaution a tramways inspector took up duty, warning passers-by not to approach the column.

The City Engineer's department is to make a thorough examination of the statue from the safety aspect today. The debris was carefully preserved by the police pending a decision by the Corporation on the future of the statue.

The monument, which rivals St Nicholas' Cathedral tower, as the city's most familiar landmark, is 130 feet high. The statue surmounting the Ionic column is the work of the sculptor Bailey. It was erected in 1838 to commemorate the services rendered to the country by Charles, Earl Grey, champion of civil and religious liberty (1764–1845).

'The Monument'

The statue of Earl Grey, which has stood for more than a hundred years in Newcastle, you may be interested to know, is the work of E. H. Bailey, a well-known sculptor of the day, and was brought to Newcastle from London by sea on the Newcastle trader 'Halcyon'.

The statue cost £700 and the Roman Doric column which it surmounts was erected at a cost of £1,600 by Joseph Welch, who built the Ouseburn Viaduct and the Bridge across the North Tyne at Bellingham.

In a chamber cut in the foundation stone is a glass bottle, hermetically sealed, containing a drawing of the memorial, a list of subscribers, a collection of silver and copper coins and local medals and tradesmen's tokens.

Earl Grey's monument, Newcastle's 130 feet landmark, has been made safe by Corporation workmen. The Estate and Property Committee has not met since the figure of Earl Grey was decapitated on July 25 but it is thought that restoration work will not be carried out until after the war.

1945: VE Day

This was the day – 7 May 1945 – Tyneside learned the Second World War was over.

Victory, after nearly six years of bitter conflict with Nazi Germany, brought the ultimate relief to a region – and a nation – exhausted by the ordeal. The following day, 8 May, would officially be VE Day.

The *Chronicle* reported that the streets became a sea of red, white and blue bunting. 'And it was,' the paper added, 'a day of gratitude and thanksgiving, with workers being sent home to enjoy a one-day holiday.'

Church bells rang, effigies of Hitler were dangled from buildings and, to the delight of children, bonfires were lit. Joyous street parties would take place across the region in the days that followed.

VE Day celebrations and 'Victory Tea' at Lambert Square, Coxlodge, Newcastle. 10 May 1945.

Evening Chronicle, Monday 7 May 1945

VICTORY
Unconditional Surrender is Announced by Doenitz

The end of the war with Germany was announced this afternoon. After 2,074 days of war, Britain has emerged victorious from the second onslaught by Germany on the peace-loving world.

The German Flensburg Radio announced this afternoon that Doenitz has ordered the unconditional surrender of all German fighting troops.

The announcement was made by Count Schwerin von Krosigk, German Foreign Minister.

He said, 'German men and women, The High Command of the armed forces has to-day, at the order of Grand-Admiral Doenitz, declared the unconditional surrender of all fighting German troops.'

'Doenitz's order', Reuter adds, 'means the end of the war in Europe'.

The war has lasted for five years and 248 days, with fierce fighting all over the world in the air, on land and sea, and under the sea, with unremitting effort and sacrifice at home.

Radio announcement tonight

With the announcement that Doenitz has ordered the unconditional surrender of all German fighting forces it is now confidently expected that the official declaration of the end of the war in Europe will be made before the day is out.

As already stated, the Prime Minister, in view of the fact that Parliament is not sitting today, will make the announcement on the wireless, but it is not possible to say in advance at what hour his broadcast will take place. It will be a brief statement declaring the end of hostilities.

In view of this definite prospect of the Prime Minister's broadcast sometime within the next few hours, it can be assumed that the King's broadcast to the nation will be made at nine o'clock tonight.

The Cabinet is in constant session today, and the wires are just between London, Washington and Moscow. Parliament will assemble tomorrow for a formal announcement, and Peers and M.P.s will then attend services of thanksgiving at St Margaret's and Westminster Abbey.

Tomorrow, which will be VE Day, and Wednesday are expected to be declared public holidays in accordance with the arrangements already announced.

Doenitz calls in U-boats

Admiral Doenitz, Hitler's successor, has ordered all U-boats to cease activity, the German Flensburg radio reported today.

According to the Stockholm newspaper, Dagens Nyheter, the Norway capitulation document has already been signed. A British military mission was expected in Sweden today to accept the capitulation.

Special Late News: Germany's Surrender

Count Krosijk's surrender announcement stated, 'Germany has succumbed to overwhelming power of her enemies. To continue would only mean senseless bloodshed and futile disintegration. The Government was compelled, for future of its nation, to act on the collapse of all forces and demand cessation of hostilities.'

Evening Chronicle: Tuesday 8 May 1945

HOW NORTH OBSERVED VICTORY DAY
Rejoicing, but no 'Mafficking'

Newcastle is all red, white, and blue today – VE Day. It was a day of joy, gratitude and thanksgiving.

The long suspense was ended. Many workers, bewildered by the unconfirmed stories of Germany's complete unconditional surrender and not sure in their interpretation of the VE Day and the VE Day plus One Day turned up for work as usual and were told to go home and celebrate.

'From an early hour today, the streets of Newcastle were crowded with men, women and children, while flags and bunting were fluttering from every shop and building. Street vendors did a roaring trade in the sale of bunting, ribbons and flags of all nations, and in the sale of a little blue document, "The last will and testament of Adolf Hitler ... public enemy number one."'

Along Scotswood Road, several effigies of Hitler were seen dangling from buildings. Many bonfires which delighted children last night were still burning today, and many more are piled high for the big Victory blaze tonight.

Tonight flares will illuminate Grey's Monument. The Town Hall and St Thomas Church will be floodlit and the lantern in the tower of St Nicholas' Cathedral will be lit.

1954: Three Bears in Newcastle City Centre

If you went down to Newcastle city centre on the afternoon of Saturday 20 March 1954, you were in for a big surprise.

The streets were packed with shoppers when amazingly, in a scene resembling a comedy farce, three bears emerged from Morden Street car park and came loping into Percy Street.

People screamed, dropped their shopping, and ran for their lives as the creatures appeared.

The bears had, in fact, been performing at the Palace Theatre in Newgate Street and escaped from a circus lorry.

Nobody was badly hurt, though one lady was scratched and bitten.

After chasing police officers around parked cars and pulling off a few car bumpers for good measure, Newcastle's very own three bears were captured.

Evening Chronicle Saturday 20 March 1954

THREE BEARS ESCAPE IN CITY: WOMAN HURT
Crowds Dash for Safety

Three bears escaped from their travelling cage in a car park at Morden Street, Newcastle, today. One of them, an adult six-foot-high on its hind legs, injured a woman in Eldon Square.

It twice knocked down Police Inspector S. J. Manging, who went to her rescue, and ripped a bumper off a car. A van driver who roped the animal had one hand scratched.

The injured woman, Mrs Mary Johnson, aged forty, a shop assistant, of 10 St Thomas' Square, Newcastle, was bitten on the back of her neck, scratched and suffered shock. After hospital treatment, she was taken home.

After a wild chase, the bears were recaptured and taken back to their cage.

Police get 999 calls

Women and children screamed and ran for shelter in shop doorways when the three bears broke through lunch time crowds into Percy Street. Police were rushed to various parts of the city where the bears were reported by people who dialled 999.

The bears, two from Canada and one from Siberia, are appearing this week at the Palace Theatre with their owner, Mr Hans Petersen, a Norwegian.

About an hour after their escape the bears were back in captivity. One was recaptured in a builder's yard in Hancock Street, another in Eldon Square and the third in the vicinity of the Morden Street car park.

Chased the police

Standing at a safe distance, crowds watched the Eldon Square runaway tear a bumper from a car and then chase a constable round another car.

Inspector Manging offered the bear some sugar, but it retaliated by hitting out and the inspector was knocked over.

At last the police managed to tether the animal to railings in the square and stood back to await the arrival of keepers.

The bear was then hustled into a police van.

Inspector Manging said that he went to rescue the woman who had been knocked down and held to the ground by the bear. He tackled it but it lashed out and knocked him over twice.

Mr John Hall, of Stratford Grove West, Newcastle, saw the crowds gathering and left his baker's van. He fetched a thick rope when he knew what was happening and managed to tie a noose and loop it over the bear's head. When he pulled the rope tight the bear hit out and caught the back of his hand with its claws, scratching it.

Mr George Bell, a British Legion car park attendant, was chased round some cars by the bears when they escaped from their truck. He said, 'I saw the three bears escaping. Two of them came out first and chased me around the cars at the top of the car park. Another then came out of the truck. It stayed in the vicinity of the car park, but the other two made off.'

The biggest bear raced through the Haymarket a few minutes before noon. Women screamed, dropped their shopping baskets, and dragged children into shop doorways.

Other people just stared incredulously as the bear loped past the South African War Memorial, dashed through traffic and crossed over to the grounds of St Thomas's Church.

PC James Maguire and PC Basil Brotherton saw the bear at Barras Bridge and chased it into a builder's yard in Hancock Street. As crowds gathered at the entrance of the yard the bear remained at the far end, but was eventually recaptured.

While photographing one of the escaped bears in Sandyford Road, Newcastle, *Evening Chronicle* photographer Ivor Schaill had his spectacles broken by the animal. 'I was trying to get a close in picture and the animal hit me on the chest with its paw and broke my spectacles, which were in my pocket,' he said.

Put into a police van

The second bear, recaptured in Eldon Square, was brought back to Morden Street car park in a police van. The third bear was recaptured after it had climbed over a wall into a yard.

Carl Neilson, aged thirty-eight, said he was working in the yard when he heard what he thought was a dog grunting. 'I turned round just in time to see a great bear charging at me. I ran away and it followed me all around the yard. It jumped over the wall when some workmen came to my help,' he said.

Elderly woman stood still.

An elderly woman had just got out of her car when the bears appeared. She was told to stand still, and did so while the bears shambled off.

The bear's trainer, Hans Petersen, said that the bears would perform as usual tonight at the Palace Theatre where he had been presenting them this week. 'The bears,' he said, 'are normally friendly. It must have been the crowd in Eldon Square that made the big one lose his friendliness.'

Asked how the bears got away, he said that apparently one animal managed to get its paws under the heavy cage opening, lift it up and scramble through, the others following.

1954: The End of Rationing

Britain imported millions of tons of food in 1939 at the start of the Second World War, so Nazi Germany targeted shipping bound for our ports.

Its aim was to starve us into surrender.

Rationing was introduced. The amount of food, petrol and clothing you could buy was strictly controlled. Everyone was given a ration book. A black market inevitably emerged.

Some have argued that the nation's health actually improved because everyone had access to a relatively varied and wholesome diet.

Bread was rationed until 1948, petrol until 1950, and the nation's children had to wait until 1953 until they could enjoy the delights of unrestricted sweets.

July 1954, finally saw meat and all other food rationing ended in Britain, but problems persisted for a while.

Evening Chronicle, Tuesday 6 July 1954

WOMEN WILL BOYCOTT PRICES FOR MEAT
We will wait for fall, say city housewives

On 'Freedom Day-plus-one' of 'Operation Meat De-ration' many Newcastle housewives today declared that they would boycott present prices for meat until there was a fall.

But a few housewives, higher prices or not, went out and bought meat today.

An *Evening Chronicle* reporter interviewed Newcastle housewives out meat shopping as they left the city's Grainger Market. Only two expressed satisfaction with the price – the rest said they would boycott present prices.

Mr W. S. Lough, President of Newcastle, Gateshead and District Butchers' Association, said today that the Association had not yet called a meeting to discuss prices. 'Although at present everything is slightly dearer, we are looking forward to certain meat commodities becoming cheaper within a few weeks,' added Mr. Lough.

And this is what the housewives said:

Mrs Alice Fairs, of Crawhall Terrace, Newcastle: 'I bought breast of English lamb at 1s 10d and was satisfied.'

Mrs Isabella Ward, of Richard Street, Newcastle: 'I am not going to buy at present prices, this week or any other week.'

Mrs Alice Sowter, of Grove Street, Elswick Road, Newcastle: 'If prices had been reasonable I would have liked some stewing meat, but at 3s per pound I cannot afford it. Instead, I bought lap of mutton at 1s per pound.'

Four Newcastle schoolchildren greet the end of sweet rationing in 1953. Rationing ended altogether in 1954.

Mrs Catherine McCabe, of Silver Lonnen, Fenham: 'I have bought no meat. I think housewives should boycott meat for a week or two to bring prices down.'

Fish preferred to fancy prices

Mrs Florence Lee, of Gladstone Street, Newcastle: 'I have had a good look around, and the meat is too dear. We will have to have fish or bacon instead.'

Mrs Mary McGeary, of Buxton Street, Newcastle: 'I bought half a pound of liver at 4s per pound. I am not going to buy beef or mutton at present prices – my husband is a barman and I just cannot afford it. How do they expect the ordinary housewife to pay the prices they are asking?'

Mrs Molly Falcus, of Redewater Road, Fenham: 'I am refraining from buying at present prices – instead of meat we will have salad, ham and fish. I am not going to pay these fancy prices.'

Mrs R Stoddart, of Gosforth: 'I bought 11/4lb. of rump steak, which cost 4s 10d and I was pleasantly surprised at the price.'

Mrs Phylis Telford, of Gainsborough Grove, Newcastle: 'I shall buy salad and boiled ham instead of meat.'

1955: Kings of Wembley

When Newcastle United skipper Jimmy Scoular accepted the FA Cup from the Queen on 7 May 1955, it was the third time in five years the coveted trophy had been lifted by the black and whites.

Indeed, in an age when the cup was the still the most revered prize in English football, this was the sixth time it would head back to Tyneside.

Sadly, and some would say incredibly, Scoular was the last Newcastle captain – to date – to lift a domestic trophy. Subsequent trips to Wembley for FA Cup finals in 1974, 1998 and 1999 would end in heartache for United.

For the Toon Army, the wait goes on.

Sunday Sun, 8 May 1955

THE QUEEN KNEW IT WAS CUP RECORD
Newcastle's Five Wembley Wins

'You have broken a record.' That was The Queen's remark to Mr Stan Seymour, chairman of Newcastle United, as the final whistle blew in Wembley Stadium yesterday afternoon.

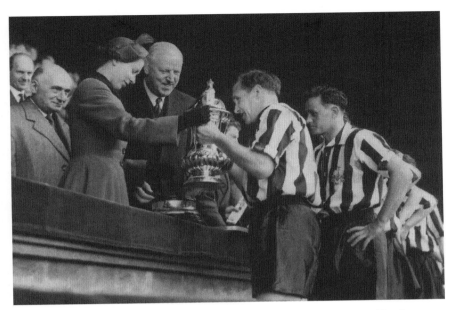

Newcastle United skipper Jimmy Scoular receives the FA Cup from Her Majesty The Queen, on May, 7, 1955, after United beat Manchester City in the final at Wembley.

The Queen and the Duke of Edinburgh – who must have supported United, for he once commanded the frigate Magpie – knew that United, conquerors of Manchester City, now hold every Wembley Cup Final.

United is the only team ever to win at Wembley on every occasion they have been there; the first team to be in ten FA Cup Finals; and this win equals the record of Blackburn Rovers and Aston Villa's six wins.

Again they are the first team to win the cup three times in five seasons and, once again, Newcastle took over the Empire's Capital last night – for it was 'Blaydon Races' all over the West End.

Another record was the quickest goal ever scored at Wembley, by 'Wor Jackie' Milburn in forty-five seconds – and from then on United were the better team.

It was Blaydon Races all the way

Thirty thousand jubilant cock-a-hoop Geordies, taking the Gallowgate road to Wembley, saw United win a 3–1 victory over Manchester City.

Amid fantastic scenes the Geordies stood cheering themselves hoarse as Jimmy Scoular, after leading his men from the field, went forward to receive the cup from the Queen.

It was a great moment – and the Newcastle fans made the most of it.

For thousands it was their third Wembley final since 1951 – and for most, yesterday's game was the best of the three.

The United fans, always proud of their cup tradition, had invaded London in confident mood. They were not forecasting who was going to win – they knew that, but they were laying odds on the score.

Within forty-five seconds of kick-off as Jackie Milburn headed his great goal from a Len White corner, pandemonium broke out. Programmes, papers, hats and caps,

black-and-white favours went in the air. From the Wembley equivalent of the 'Bob End' to the right of the royal box, where the Geordies seemed stacked tier on tier, a mighty full-throated roar erupted. It echoed miles over London.

The game was fast. 'Blaydon Races' from 50,000 throats time and again drowned the counter cheers of the Manchester City contingents.

The Geordies were confident that more goals would follow. But for the brilliant play of City's goalkeeper, Trautmann, United would have had several more.

Then for Manchester came disaster as Jimmy Meadows was taken off, not to appear on the field after half time. 'Mind, we were sorry about this,' said Owen Monoghan, a miner of Bedlington 'D' Pit, who lives at Haig Road, Bedlington. 'I don't like to see a man go down – but mind you it would have made no difference to the score – we were definitely the better team.'

Owen was in the middle of the vast, cheering Geordie contingent. With him was Bob Little, from Weetslade Colliery, who said, 'My, it's a great match, but I think we missed a couple of chances.'

Man of Match

It did not take Billy Hunter, a bookmaker's clerk, of 16 West View, Bedlington Station, long to decide that Bobbie Mitchell was his Man of the Match. 'My, didn't he diddle 'em. He got them het up like sausages in a frying pan.'

For two Newcastle women supporters who have championed United at St James' Park for twenty years it was a display worth travelling 550 miles for.

For Mrs Margaret Ryder, of Wharncliffe Street, who sported a Magpie scarf, and Mrs Catherine Moesby, of Ratcliffe Place, North Fenham, it was ninety minutes of non-stop 'Oh, so exciting' football.

1959: Fire in Newcastle

An afternoon of drama witnessed by 20,000 onlookers unfolded in Newcastle in August, 1959.

This was a time when the city was still a thriving industrial, manufacturing and maritime centre. As such, there were warehouses aplenty, like this one in New Bridge Street packed with goods and appliances, which were potential tinder boxes.

Indeed, only three months after this incident, two boys narrowly escaped death when another major warehouse fire broke out in the same street.

Thankfully, no one was hurt in this blaze, but it did a huge amount of damage.

The fact that the fire melted trolley wires, stopped trains, and threatened a petrol station is an indication of its size.

Evening Chronicle, Monday 17 August 1959

GIANT WAREHOUSE FIRE RAVAGES CITY STREET
Trolley Wires Melt, Trains Stop, Petrol Menaced, Flames Leap Across Road

Twenty thousand people watched a dramatic battle by firemen as flames surged through a huge, five-storey Newcastle warehouse this afternoon.

A dense smoke pall hung over New Bridge Street as the roof fell in and floors gave way. There was £35,000 worth of stock on one floor alone.

Traffic was stopped as flames leapt across the road, threatening other buildings, including a petrol station. At the rear, the blaze spread to a platform on Manors Station.

Electric trains from the coast were stopped at Jesmond station and re-routed as flames enveloped the 60-foot high building. Crowds were held at a safe distance.

Charred girders fell with a roar and a Manors Station official just managed to jump clear. The building houses the district depots of the firm of Hotpoint, Tyres (Scotland) Ltd, Philips Electrical Ltd, the New Bridge Street Post Office, the Wesleyan General District Assurance office and Summerfield Ltd wholesale distributors.

Workers in the building were evacuated and had time to get out without danger. About £10,000 to £11,000 worth of tyres were stored in the lower section of the building. Thousands of pounds worth of electric washers and other household electrical equipment are known to have been in the building. The upper part of the building was severely damaged in a fire about two years ago.

Ann Sanderson, a twenty-year-old typist employed by Tyres (Scotland) Ltd, which occupies the ground floor, said the fire had apparently started in the back of the building

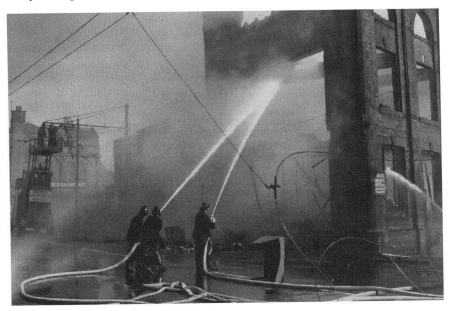

Firefighters tackle a major blaze at a warehouse in New Bridge Street, Newcastle 1959.

and the flames then swept through the premises. 'We were told to clear out as the fire was likely to be a big one,' she said. 'The fire had come through the ground floor and was spreading quickly.'

1960: Loch Ness Monster 'Discovered'

It's one of the most celebrated mysteries of all time, and in 1960 it made the pages of the *Evening Chronicle*.

A local fireman, and former naval frogman, contacted the paper claiming he'd taken pictures of the mythical Loch Ness Monster. It was, he claimed, proof of the beast's existence. In today's more cynical, worldly-wise world, it's doubtful whether such a story would be given much credence. Back then, it was happily splashed all over page one.

The dismissive, official response of Newcastle's Hancock Museum effectively put paid to our fireman's claims. But, decades later, the riddle of Nessie still hits the headlines from time to time, and has yet to be solved one way or the other.

Saturday 11 June 1960

THE LOCH NESS MONSTER
'This is it', North Fireman says, 'I Took a Picture after 6.00 a.m. Vigil'

A fireman says he has photographed the fabulous Loch Ness Monster.

The fireman, and ex-Royal Marine frogman Peter O'Connor of Swinburne Place, Gateshead, claims he photographed the monster between 6.00 a.m. and 6.30 a.m. on Friday, 27 May, about a mile north east of Foyers Bay on Loch Ness.

He was accompanied by a member of his survey team, Mr Fred Fulcher of Swindon Street, Hebburn, and although conditions were not ideal for photography and the creature appeared in half light, they were satisfied by what they saw.

'It was exactly what we had been looking for,' said Mr O'Connor. 'She was riding high in the water with two or three feet of head and neck, and about three feet six inches of the back showing. We had expected no more than 18 inches to be showing.' He said today that he and a team of naturalists had built up a good picture of the monster's habits and mannerisms.

They believe 'Nessie' is a creature with a large, broad flattened body with four paddle-like limbs. The tail is short and otter-like and a small head similar to that of a sheep's is set on a long, thick neck. Colour is a blackish grey and the texture of the skin observed from 25 yards appears smooth but is probably composed of fine scales. Teeth appear to be primitive fish teeth, and the eyes are large and prominent as in a nocturnal creature.

'The monster', says Mr O'Connor, 'lies at a depth between 40 and 150 feet and occasionally uses the surface during the day to bask. At night it surfaces more frequently, possibly to hunt food. By nature it is timid and shy of man and noise. Its strongest sense appears to be smell, and it is capable of speeds between 20 and 30 knots.'

The monster, now officially recognised by the Northern Naturalists' Organisation, today received its scientific name. The name Nessiesaurus O'Connori commemorates the name of Mr O'Connor and the fact that he believes it to be a descendant of a prehistoric reptile called a plestosaur.

Mr O'Connor regards recognition by the Northern Naturalists' Organisation and naming of the creature as very important to his plans to catch the monster. 'I have worked out a perfect method of catching it which involves getting the creature into a cage,' he said. 'What we need is a sponsor to finance the purchase of proper equipment for the trip. Recognition will help in that direction.'

When shown the picture today, Mr A. M. Tynan, curator of the Hancock Museum, Newcastle, said, 'In view of the unsatisfactory condition of the evidence, we are not prepared to make any pronouncement.'

1962: Blaydon Races centenary

'Gannin' along the Scotswood Road to see the Blaydon Races...'

Geordie Ridley's world-famous music hall song is the undisputed anthem of Tyneside. Written in 1862, and first performed at Balmbra's in Newcastle's Cloth Market, its verses tell of a boisterous journey across town to the annual horse races in Blaydon. Thousands would flock to the event, the first record of which is in 1811.

Surviving three changes of location over the decades, the Blaydon Races was last held in 1916 as the First World War raged in Europe. A dispute over the winner of one race led to a riot – and the races were subsequently banned. The Blaydon Races are still commemorated by an annual road race.

In 1962, the 100th anniversary of the song's first rendition sparked major celebrations in Newcastle.

Evening Chronicle, Saturday 9 June 1962

GANNIN' ALONG THE ROAD TO BLAYDON
Huge Crowds out in the Sun for Tyneside's Big Day

Scotswood Road burst exuberantly into life this afternoon as the old Geordie spirit of enjoyment came bubbling through on the crest of the Blaydon Races centenary

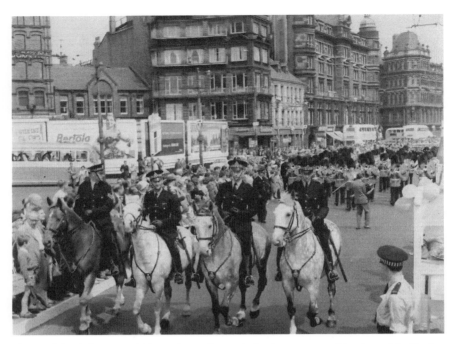

Thousands lined the streets of Newcastle on 9 June 1962, for the centenary celebrations of the Blaydon Races.

celebrations. For on 9 June 1962, the old route blossomed with a forest of flags and bunting in readiness for one of the greatest parades in Newcastle's history.

Promptly at 1.30 p.m. the centenary parade rolled off from Balmbra's in the Cloth Market, Newcastle, heading along the Scotswood Road to Blaydon. Balmbra's was where the celebrations had started a little earlier, when the Lord Mayor, Ald George Jacobson, held a reception. But when all his guests were assembled, the Lord Mayor formally renamed the Carlton, Balmbra's, the name immortalised in Geordie Ridley's song.

The old time music hall got off to the swing of can-can girls and a short sample of the entertainment to be offered later to the public.

Incongruous

Attracted by warm sunshine, large crowds gathered early outside the reconstructed Balmbra's for the start of the grand Blaydon Races parade. Hours before the parade was due to start, police were on duty to control the many sightseers who had turned up – many of them with cine cameras.

Shortly before the reception at Balmbra's, the waiting crowds saw the incongruous sight of the many guests arriving in 1862-style clothes, yet getting out of the latest line in motor cars at Balmbra's door.

Among the 300 guests at the official opening were Mr Hugh Gaitskell and civic chiefs from Newcastle and Blaydon.

A roar

Mr Vernon Parker, managing director of United Yorkshire Breweries, owners of Balmbra's, told them: 'I'm sure our grandfathers enjoyed life with a rumbustic gaiety

that makes present day entertainment pallid by comparison.' There was a great roar from the crowd as the band of the Coldstream Guards struck up 'The Blaydon Races' and the vanguard of the procession moved off from the Cloth Market.

As it moved along Scotswood Road it picked up more and more contingents, and altogether there were estimated to be 160 floats and sixty bands taking part. After the guards came contingents of the armed forces and then the Lord Mayor's coach.

Members of the Blaydon Races Centenary Committee followed in an old Newcastle Corporation horse-drawn bus. All were dressed in period costume and, led by their chairman, Cull Leslie Cuthbertsen, they treated the crowds to 'The Blaydon Races'.

The committee received souvenir tickets from a punch lent by Mr Ian Mair, the rolling stock engineer of Newcastle Transport Department. The punch is at least 150 years old and has been used all this week while the bus has been making trips from Eldon Square.

Loud cheers

There were loud cheers from the crowd for Balmbra's bevy of can-can girls. The three-mile-long procession stretched the entire length of Scotswood Road and took at least two hours to pass. Among the scores of floats, the *Evening Chronicle*, *The Journal* and the *Sunday Sun* showed two young printers, Mr W. Cribbs and Mr F. Eliott, operating a 130-year-old hand press.

With it on the float – one of the lorries used for delivering the great rolls of newsprint – a tableau represented the present role of the three newspapers in the modern life of Tyneside.

Fantastic

All day, groups of people burst again and again into choruses from Blaydon Races. It was the most fantastic day Tyneside has known for years. Tens of thousands of happy, singing people lined Scotswood Road in the afternoon sunshine.

Every float, every band and every little marching group was greeted with enthusiastic roars of applause. One bystander said, 'This is the best thing that has happened here for a long time.'

In the traditional manner, many people celebrated with street parties for the first time since the Coronation. Competitors from all over England and Scotland arrived at Blaydon for the galloping and trotting racing this afternoon.

In Newcastle, the evening will bring the opening of Balmbra's to the general public.

1963: Winter

1963 witnessed one of the worst winters in British recorded history as temperatures plummeted so low even the sea froze. The snow started on Boxing Day, 1962 and the big freeze lasted until March. Lakes and rivers froze across the country amid biting

temperatures, and there were patches of ice on the sea. Blizzards caused snowdrifts up to 20 foot deep.

Arctic conditions across Britain meant thousands of schools closed, telephone lines were brought down, and power cuts hit thousands of homes. Temperatures dropped as low as 22.2 Celsius on 18 January 1963, in Aberdeenshire.

The freezing weather meant there was no football played at Newcastle United's St James' Park from mid-December 1962 until mid-March 1963.

Evening Chronicle, Friday 1 February 1963

CITY TRAFFIC CRAWLS IN 'WORST' BLIZZARD
Breakdowns by the Score Bring Jams and Chaos

In one of the worst blizzards of the winter, traffic in Newcastle and throughout Tyneside slowed to a crawl this afternoon following heavy falls of snow, of from three to six inches. Many crashes were reported on the snow-covered icy roads.

Newcastle United manager Joe Harvey and players clear snow from the pitch at St James' Park, 1 February 1963.

A spokesman for the RAC this afternoon said, 'Conditions in Newcastle city centre are pretty chaotic. We have had so many breakdowns that we are having difficulty coping with them. In some parts of the city it is so bad that our vans are getting into trouble. Outside the city it's even worse.'

The steady fall of snow was thwarting every effort of Gateshead Cleansing Department and a police spokesman said this afternoon that traffic was slowly grinding to a halt in the town.

Blizzard

On West Street, probably the most affected road in Gateshead, traffic was constantly lining up as individual vehicles were failing to get up the gradient. Congestion here was causing long line-ups in the rest of the town. 'There isn't a clear road in the north east,' said a spokesman for the Automobile Association this afternoon. 'All roads have a covering of snow. Conditions are getting worse every hour and it is easily as bad now as it was at the beginning of January.'

The spokesman said the main trouble was being caused by lorries getting stuck on hills and blocking the road. During the afternoon, blizzard-like weather hit Tyneside and the sky looked full of snow.

Escape

Mr Allan Henderson, coroner for Durham East Chester ward, was twenty minutes late for a South Shields inquest today after he was involved in a road accident at Gateshead. Mr Henderson told the *Evening Chronicle*, 'There was nothing I could do about it. I was at the corner of Victoria Road, Gateshead, when I had to brake sharply to avoid a lorry. Another lorry following collided with the back of my car. Fortunately, nobody was injured and I was able to continue on my way to South Shields.'

Mr Henderson, a Newcastle solicitor, lives in Brookside, Millfield Road, Riding Mill. Meanwhile, passengers on a Newcastle Corporation bus, and six people waiting to board it, had a lucky escape from injury when it collided with a lamp standard in Archbold Terrace, Jesmond.

1963: The Beatles in Newcastle

This was the year the phenomenon of Beatlemania arrived on Tyneside.

Hailing from Liverpool, the Fab Four would spark a musical and cultural revolution across Britain, the United States and beyond. John Lennon, Paul McCartney, George Harrison and Ringo Starr would play in Newcastle five times during 1963.

There were two shows at the Majestic Ballroom on the city's Westgate Road (it remains a music venue in the shape of the O2 Academy) and three shows at the City Hall. Our article comes from the last show they'd play in Newcastle that year, and it was one which clearly left a lasting impression on the *Chronicle*'s unfortunate reporter.

Evening Chronicle, Monday 25 November 1963

THESE SCREAMING FANS BEAT THE BEATLES BEAT

If you ever wondered what Baron Frankenstein must have felt like when he realised what a monster he had created, put yourself in the shoes of a small group of journalists (myself among them) who first recognised and publicised a quaintly named recording group now universally acclaimed as The Beatles.

Until Saturday night my acquaintance with the Liverpool lads had been that ideal combination of pleasure and power which control of a volume knob or a television switch gives one. Then I was pitched headlong into a vortex of mass hysteria the like of which I have not seen since I witnessed the almost unbelievable vilification of Mussolini's corpse in Milan at the end of the war.

Newcastle's City Hall reverberated to the rhythmic stamp of more than 2,000 pairs of feet and the decibel levels rose well beyond tolerance level as 2,000 teenagers screamed themselves hoarse and effectively destroyed any chance of hearing the very sounds they had queued for hours and paid good money to listen to.

Solid phalanxes of gyrating bodies and imploring, outstretched arms blotted out the view of the stage and the sweating shouting performers.

Fever pitch was reached and passed. The fans had whipped themselves into a near-delirium in which nothing mattered but that they were involved in the mass adulation of The Beatles.

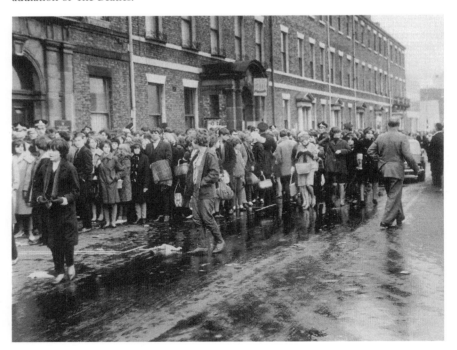

It's October 1963, and Beatlemania has arrived. Crowds queue for tickets for the Fab Four's Newcastle City Hall show on 23 November.

To them it was 'fab', though if they heard one word or caught one strangled guitar chord of that futile projection from the stage, they achieved more than I did. I came away however, with a new admiration for the City Hall stewards (whom I had joined in a rash moment of enterprise and enthusiasm).

They filled a role as modern Canutes trying to stem a tide of exuberance which was frightening in its intensity. They did it with unfailing good humour and not a little tolerance. The fact that the City Hall is still serviceable speaks volumes for their skill and ingenuity.

My own amateurish efforts in answering a myriad questions, prising interlopers out of seats to which they were not entitled, arbitrating between rival contenders, mollifying disappointment and preventing over-zealous participation in the rites which were being conducted, brought me aching feet, a throbbing headache, and ear-drums which have not yet fully recovered their full use.

Oh, for a quiet concert – the 1812 Overture, or the soothing normality of The Planets, for example!

1969: Europe Conquered

At the end of the 1967/68 season, Newcastle United managed to finish tenth and qualify for the Inter City Fairs Cup. In later years it would be re-named the UEFA Cup, and this was the Magpies' first flirtation with European football.

The Toon Army took the competition to their hearts, packing out St James' Park as the black-and-whites dumped out quality opposition from Holland, Portugal, Spain and Scotland on their way to the final.

Over two legs from May to June 1969, United dramatically beat Ujpest Dozsa of Hungary 6–2 on aggregate. Defender Bobby Moncur, who scored three of the six goals remains, to date, the last Newcastle United skipper to lift a major trophy.

Evening Chronicle, Thursday 12 June 1969

FANS WAIT FIVE HOURS TO SEE FAIRS CUP HEROES

Once more on the roll call of honour after fourteen barren years, Newcastle United are bringing the Fairs Cup home to a heroes' reception from an adoring Tyneside.

Budapest and all of Hungary has already fallen for the mighty Magpies who outfought sixty-tree other clubs for the right to receive the Fairs Cup from the hands of Sir Stanley Rous.

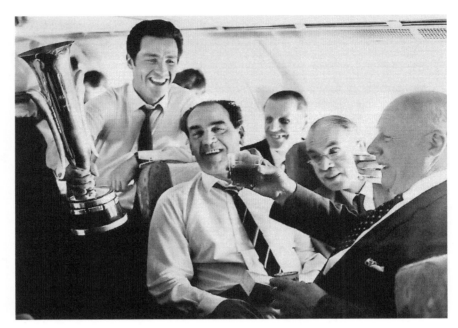

Newcastle United skipper Bobby Moncur, manager Joe Harvey, and club directors fly home with the Inter City Fairs Cup in June 1969.

Now, tonight at Gallowgate, United are bringing 'the pot' to the people who matter – the people manager Joe Harvey calls the greatest. As the players drank from the cup in Hungary last night and sang 'Happy Birthday' to an emotional Joe Harvey, the United manager said, 'My only regret is that the bulk of our fans could not see us get the cup. We owe so much to them. But next season we'll win the Fairs Cup at Gallowgate for them.'

Beating Ujpest Dozsa has stunned all Europe and brought this accolade from Football League secretary, Alan Hardaker: 'Newcastle United struck a blow for English soccer in Budapest. I was so proud of them. If George Best had scored the third goal Alan Foggon got, the world would never have stopped talking about it. It was absolutely brilliant – the perfect end to a wonderful night.'

The scenes in the dressing room immediately after the match were highly emotional. Chairman Lord Westwood hugged every player and said, 'What a wonderful team. I'm so proud of my boys. No one on Tyneside had a right to expect as much as this.'

Special praise is due to Bobby Moncur, the undoubted north east footballer of the year, and to the backroom boys, Joe Harvey, and coach Dave Smith. Between them, these three have inspired a long-overdue but nonetheless unexpected resurgence of football on Tyneside.

The faithful fans have richly deserved it and they can now hope that this is but the first exciting page of a glorious new chapter in Newcastle United's chequered history.

Meanwhile, five hours before victorious Newcastle United were due to drive in triumph through the city with the Fairs Cup, crowds started gathering to give them a heroes' welcome.

United's plane was due to touch down at 4.55 p.m. and the party was to travel to St James' Park by coach.

The ground itself was open to supporters, and manager Joe Harvey and Captain Bobby Moncur were to lead the team in a parade around the ground with the cup.

Scores of Tyneside schoolchildren have left classes early to welcome the team home.

1969: The £2m Blaze

Callers was a popular city centre furniture store on Newcastle's Northumberland Street.

Its annual Christmas window features pre-dated the famous festive displays at nearby Fenwick's.

On Sunday, November 30, 1969, a mechanical character in the Callers' display caught fire, sparking a huge blaze which gutted the store and led to £2m of damage.

Over 100 firemen, armed with three turntable ladders, took hours to bring the blaze under control. Thankfully, only three people were injured.

Callers reopened on its original site after a year and continued to trade until the early 1980s.

It was later a toy shop, a record store, and is today a sports equipment retailer.

Evening Chronicle, Monday 1 December 1969

DEMOLTION MEN MOVE IN ON WRECKED STORE
The Big Blaze: Main Street Stays Blocked

Northumberland Street will be closed to traffic until late tomorrow afternoon as demolition men move in to make the tottering facade of Callers giant furniture store safe after last night's blaze.

This was learned today after many weary firemen who had fought the huge blaze throughout the night inspected the ruins with an official of the city engineer's department. A snorkel fire appliance took Mr Fred Didsbury to roof level. Then he announced, 'The top of the building will have to come off.'

Mr Didsbury said, 'We'll have to lift the two pinnacles from the front of the building and a balcony. We cannot let these drop into the street or inside the building so they will have to be lifted off with cranes. The top of the building is dangerous. We'll also have to knock a large chimney and gable end down.'

Mr Didsbury said contractors had already been called and the work would begin today.

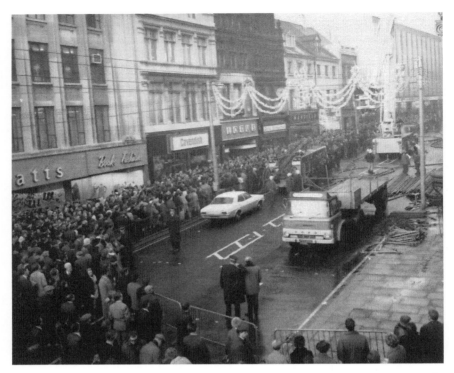

Christmas shoppers watch the aftermath of the fire that destroyed Callers store, Newcastle, 1 December 1969.

£2 million loss. It is now known that the blaze hit not only Callers and the adjoining Michael's night club, but also two fashion shops, Richard Shops and Van Allans.

Other nearby buildings were affected by smoke and water but were not badly damaged. A conservative estimate of the loss is put at well over £2 million. The building alone was worth £1 million.

Callers will continue to do business in temporary premises offered by the City Corporation. The building is W. Ferguson's former showroom in Prudhoe Street, acquired for redevelopment but not needed for that purpose yet. Payments by customers were today being received in Saville Row and inquiries concerning travel and holidays were being handled at the headquarters in Osborne Terrace, Jesmond. But the brothers who own the shop, Mr Roy and Mr Ian Caller, have suffered more than a financial loss. As his brother stared at the rubble-strewn windows of the store today, Mr Roy Caller said they had been into the building and the safes with the firm's papers were still in the basement.

Uninsured

He said, 'Whether our records and papers are still intact, we cannot tell. It has not sunk in yet that the place is gone. We were established in 1897 by my grandfather. We moved here from New Bridge Street in 1929.'

For forty-year-old Mr Michael Michaelides, proprietor of Michael's Club, gutted in the blaze, last night's fire meant a cash loss of £150,000. He said today, 'I am not insured. Our main problem now is providing alternative accommodation for our bookings.'

Speaking from the Hedgfield County Hotel at Ryton, which he also owns, Mr Michaelides said, 'I will try to get as many guests as possible in here at the hotel in Ryton, but I need a large hall with cooking facilities in Newcastle as soon as possible. I have lost about £150,000. All I can do now is to wait until the landlords repair the building.'

Red glow

And at the club, musicians John McGarry and his colleague Jimmy Allen, part of the Allen James Group, searched the debris of the Spanish Room for the remains of £1,000 worth of equipment which they lost in the blaze.

The Caller brothers watched throughout the night as 100 firemen using twenty machines battled to contain the blaze.

1970: *Get Carter*

The classic gangster film *Get Carter* needs little introduction.

Starring Michael Caine, it tells the violent tale of London gangster, Jack Carter, who returns to his home city, Newcastle, to avenge the murder of his brother. The movie was, of course, shot in the north east, and used the people and places of the region as a backdrop to the action.

The atmospheric footage captures the region at a pivotal time in its history. Established industries were dying and the old terraced houses would soon be bulldozed.

The use of local bystanders as extras also gave the film a powerfully authentic feel. It was shot over forty days between July and September 1970.

The Journal, Thursday 10 September 1970

GET CARTER AND THE SACKED CHAMBERMAID

A chambermaid, who claimed last night she was sacked from Newcastle's four-star Royal Station Hotel for seeking film star Michael Caine's autograph, is being asked back to work by the hotel manager, Mr Victor Woodcock.

He said last night, 'I have personally written her a letter asking her to call me and clarify the situation. The job is still open. I can assure you she has not been given the sack. Only I give the staff notice, and I have not given anyone their notice. We are wondering why she has not turned up for work.'

The trouble started when the chambermaid, thirty-six, was asked by two of the hotel's cleaners to get Mr Caine's autograph. 'I went to the first floor where Mr Caine

Actor Michael Caine on Westgate Road, Newcastle, 27 July 1970, taking time out from filming the gangster movie *Get Carter.*

has his suite at 9.30 a.m. on Sunday morning,' she said last night. 'I saw a woman being handed Mr Caine's breakfast and asked her if Mr Caine wouldn't mind signing two autographs, and handed her two slips of notepaper. She said that Mr Caine had had no sleep, but she took them and I never gave it another thought. About half-an-hour later I was summoned to see the housekeeper, Mrs Jarvis, and given a right roasting. I was given a week's notice and taken to see the assistant manager who said I had done a silly thing. Later I was cleaning the bedroom of the producer of the film, and he told me not to worry because I wouldn't get the sack. I told him I already had, then decided to leave right away, took off my apron and left.'

She added, 'I never did get the autographs.' The worker who had been working in the 141-bedroom hotel as a charlady for three weeks, earning £9 15s a week, had temporarily been upgraded to chambermaid just before the incident.

Mr Brian Doyle, MGM's press officer said yesterday: 'Mr Caine was not annoyed at all. He asked the manager not to sack the woman.' Meanwhile, a dark secret of the actor Michael Caine who is making the film *Get Carter* in Newcastle can be revealed today.

It is this: The dare-devil hero of films such as the *Italian Job* is not much of an expert behind the wheel. In fact, he cannot drive.

Caine does have a car, a Rolls Royce. The problem for him is to get insurance. A learner driver actor with a Rolls Royce is not a favoured customer with insurance companies.

A stunt man stands in for him in the film-driving scenes.

Bang goes another myth.

1972: Handyside Arcade

The indoor Handyside Arcade — with its range of quirky shops — was hailed as Tyneside's answer to Carnaby Street at the peak of the swinging 60s' boutique boom.

By the late 1970s/early 1980s, it had become a Saturday haven for rock music fans who would gather at shops like Kard Bar and Fynd. The arcade was the brainchild of George Handyside. It opened in 1906.

During the First World War it was used as a barracks; it became derelict during the Depression, but enjoyed a renaissance in the 1960s, selling everything from hamsters to hi-fi. By 1987 the controversial decision was made to demolish it. It was replaced by Eldon Garden shopping mall.

The Journal, Friday 5 May 1972

TODAY'S ARCADIANS HAVE A SENSE OF ADVENTURE

At the height of the boutique boom of the 1960s, Newcastle's Handyside Arcade was dubbed Tyneside's own Carnaby Street.

But the great boutique bubble burst and the arcade is seeking to identify itself as a grand bazaar, although primarily catering for the demands of a modern generation. Pop posters, bootleg records, steel jewellery, books on eastern religions and cults, underground magazines, way-out sounds by strangely named groups and, of course, strobe lighting are all available. Yet the arcade also has shops selling bicycles and coins, and it has an electrical wholesaler. Or you can have your watch and clock repaired.

Arcadia was the promised land of George Handyside, the son of a Northumberland labourer who rose to be both a highly successful and eccentric business tycoon. He wanted to build about 100 shops in the arcade off Percy Street.

In February 1903, he was given the go-ahead by Newcastle Corporation to build fifty-six. But in the May of the following year, Handyside died while his arcade was still being built. Handyside, after whom the arcade is named, made his money as a boot and shoe manufacturer, tanner and curer of leather. As a youth of sixteen, he left his home at Newton-on-the-Moor, near Felton, to start up in business in Berwick. He had 17s in capital. Four years later he expanded his boot and shoe manufacturing business to Newcastle. It was the start of a career which would make him one of the big shopkeepers in the north.

At the time of his death, he owned 50 shops in all the major towns and cities between Newcastle and Aberdeen. Today, he would be classed as a speculative property developer. For as well as controlling shops, he also built shops for sale.

Today, Handyside would have probably endorsed all that is going on in his Arcadia.

Among the traders there is a sense of adventure which would have appealed to the arcade developer.

Handyside Arcade, Newcastle, in September 1986.

The pop poster shop has probably the most extensive range of posters on Tyneside. It also seems right that there should be a couple of second-hand bookshops which are interesting to browse around and where no sales pressure is applied. The coin shop too, is as interesting as any. Here half-crowns are sold at 25pence and 50pence, depending on year and condition. Now there is only one dress shop, but there is an interesting gallery selling prints and women's accessories such as bags in the latest colours and designs. But there are empty shops in the arcade being renovated.

Perhaps when they are tenanted, the arcade will once again be a kind of King's Road and Carnaby Street.

1973: Likely Lad Interview

Whatever Happened to the Likely Lads was one of the most popular TV series' of the 1970s. The colour TV follow-up to the original mid-60s Likely Lads, the comedy focused on the ups and downs of two lifelong pals, Terry Collier and Bob Ferris.

Purportedly set in Newcastle, the two main characters were actually played by Sunderland-born James Bolam and Yorkshireman Rodney Bewes. Their last outing was in the 1976 movie version of the Likely Lads, soon after which the pair fell out and never spoke again.

Despite widespread public affection for the show, in later years Bolam was increasingly less than enamoured with his one-time character and a sequel was sadly never on the cards.

Evening Chronicle, Thursday 22 March 1973

LIKE TERRY? NOT LIKELY
James Bolam Isn't Really one of the Lads

The farm is a mile down the road from Hartley Wintney in rural Hampshire. You can see other buildings from the windows so it's not isolated. But it is pleasantly secluded.

It is also the country home of James Bolam, the 34-year-old actor who portrays Terry Collier in the successful television comedy series, *Whatever Happened to the Likely Lads?*

Bolam has a house in Fulham, too, but he appears to be happiest in the Hampshire countryside. In fact, the farm is rented, but he is looking for a property to buy.

Clearly, Bolam is far removed from the character he plays in the BBC series, which is set in the north east, a tough area of harsh skylines. This is apparent when you speak to him. 'I'm not Terry Collier. I'm me, Jimmy Bolam, the actor. I hate it when the public confuses the two. I go into people's front rooms as Terry, but it should end there. I want it to end there.'

He agrees there are actors who help perpetuate the images they create. 'They get a role and live off it for years. They lose themselves and their identities. But that's not for me.' His attitude explains, at least in part, why Bolam, in spite of the success of The Likely Lads, is not happy being interviewed. Another reason, perhaps, is a distrust of journalists, stemming from articles in which he has been misquoted.

This was the first time he had agreed to be interviewed since the series returned to television in January. 'When Rodney Bewes (the other Likely Lad) was married the other week, everybody expected me to be there. "How could Terry stay away from Bob's wedding," they asked. But we aren't friends. We work together, that's all.'

Bolam the actor and Collier the character have one thing in common, a north east background. Bolam was born in Sunderland, educated at the Bede Grammar School,

Actors Rodney Bewes and James Bolam of 'Whatever Happened To The Likely Lads' on location in Tyneside with head of comedy at the BBC, James Gilbert, 1973.

and there decided he wanted to be an actor. This speaks volumes for his determination because this reporter too was born in Sunderland and educated at the same school, and can speak with knowledge when I say it was not one of the country's cultural centres.

We share a recollection of the school's dramatic society presenting 'The Ascent of F6'. Bolam was not a member – it could have scarred him for life! Nor did it succeed in dissuading him from becoming an actor.

There is a real element of the north east in the dialogue of The Likely Lads and in Bolam's interpretation of the role. Any Geordie can recognise it immediately.

Yet Bolam left behind any feelings for the area when he moved to Derby as a young man. He explained, 'I hate nationalism of any sort, like supporting a particular football team.' Bolam completed filming the current series of *Whatever Happened to the Likely Lads* in January and will do another in the summer.

1975: 'Rollermania'

If you were a teenage girl in the mid-70s, you were more than likely a fan of the Bay City Rollers.

Ten years after Beatlemania, the five-piece Edinburgh pop band sparked similar scenes of mass hysteria across Britain. Lacking the long-term cultural or musical impact of the Fab Four, Rollermania came and went quickly but sparked a whole lot of screaming among hordes of tartan-clad teeny-bopper fans up and down the country.

The Rollers arrived at Newcastle City Hall in May 1975 with 'Bye Bye Baby Love', their biggest ever hit, sitting at the top of the singles charts.

Mayhem ensued and, thankfully, a *Chronicle* reporter was on hand to witness it all.

Evening Chronicle, Wednesday 7 May 1975

PANDEMONIUM – AND ABOVE EVERYTHING, THE SOUND OF SPLINTERING SEATS

Pandemonium – that's the only word to describe the incredible scenes at the end of the Bay City Rollers concert.

Hysterical fans watching the Bay City Rollers at Newcastle City Hall on 7 May 1975.

When the top group appeared at the City Hall, Newcastle, it took more than seventy police, forty special stewards and the entire staff of the concert hall to control the screaming crowd of more than 2,400 girls inside the hall – and 1,000-plus outside. I remember the visits of the Beatles and the Stones, but I've never seen anything like this before.

It started at just after six, when an already hysterical girl who had somehow climbed through a rear window was carried sobbing from the backstage area by a police sergeant. From then it steadily got worse.

The mob outside were prevented from reaching the stage door by a cordon of police stretched out along College Street. And the screaming and chanting began when the doors to the hall were opened just after 7.00 p.m. Even before the concert started young girls – some only eleven or twelve-years-old – sat on the edges of their seats and cried. Others, with tears streaming down their cheeks, chanted the name of the group.

During the first half of the show the hysteria mounted as the support group, Chips, played and then compere, Dave Eager, had the unenviable task of announcing the Bay City Rollers. Even with the public address system at full blast, he could hardly be heard.

Backstage, the group were cool and calm. Shortly after finishing a sound check at 6.45 p.m. they returned to their dressing room and stayed there with a burly security guard on the door.

Even so, they looked apprehensive as they approached the stage. And when they finally arrived in front of the crowd things began to go wrong. For a while the audience was at top decibel pitch, but ordered. Then one girl, wearing a tartan tam and with her jacket covered in Bay City Rollers badges, flung herself at the stage. Hundreds followed her.

Only the group could hear the music they played, it was impossible to find out the number they were performing, even by standing in front of the enormous speakers at the front of the stage. And I didn't stand there very long. For soon the front stage area was a swaying mass of girls, six-deep, each struggling to get on to the stage.

Security guards threw young fans back into their places as soon as they moved – they couldn't do anything else. Above everything else came the sounds of splintering seats as the front three rows gave way under the pressure of the hysterical girls.

Some tried to grab the group, others pulled at cables and at the clothes of City Hall staff.

Then came a lull as the Rollers left the stage – they were five worried boys, and their manager, Tam Paton, was even more concerned about the possibilities of someone getting seriously hurt.

St John's Ambulance men led sobbing teenagers to a special recovery room in the front of the hall. But with the second appearance of the BCR on the stage, it became more like a riot. I saw girls trampled in the crush, and colleague Mike Blenkinsop, out in the fray taking pictures, went under and only just managed to regain his feet in time before another row of seats buckled under the orderless crowd.

The Rollers played their last number – and ran. Out into a waiting van they went with manager and press man and were driven off at high speed, covered by rugs.

The fans were unable to believe that they had left, and continued to chant and scream. Others sat on seats as the hall was cleared and screamed with uncontrolled

panic and hysteria. One girl was dragged clear by ambulance men and yelled four-letter abuse at them.

200 girls and young men outside the hall surrounded a van they thought contained the group and pounded on it until police arrived and prevented it from being overturned. An ambulance arrived to take away injured fans and City Hall staff still struggled with youngsters in a bid to clear the auditorium and foyer. None would believe that their idols had left, and more than thirty minutes after the end of the concert there were still more than 1,000 shouting slogans and chants outside.

Slowly, they dispersed. Young girls clutched souvenirs of the visit and still sobbed the names of members of the group. Inside, staff swept up chairs splintered to matchwood and picked up dozens of silver bracelets thrown on to the stage. Everywhere there was tartan litter – caps, scarves, posters, badges.

One security man pushed to the ground and slowly recovering from the ordeal told me, 'That was nothing less than a riot – I wouldn't go through it again for all the tea in China.'

1976: Retail Revolution

Taking its name from the nearby grand nineteenth-century Newcastle Terrace, Eldon Square Shopping Centre first opened its doors in 1976. Officially opened by Queen Elizabeth II a year later, it was the region's first major indoor shopping mall, pre-dating Gateshead's Metrocentre by a decade.

To some extent, it symbolised the move from traditional high-street shopping to a new, American-style retail mall experience. Eldon Square – Britain's biggest shopping centre at the time it was built – is home to most of the nation's leading retailers. With around 150 stores across 130,000 square metres of floor space, the centre attracts tens of thousands of shoppers every week.

Evening Chronicle, Saturday 16 March 1976

IT'S THE ELDON SQUARE GOLD RUSH

Tremendous. Fantastic. Amazing. That's what traders are saying about Eldon Square.

For takings in Newcastle's £60 million shopping centre are beyond their wildest dreams – and the complex has just opened. Eldon Square's shopping bag army has set the cash tills ringing up an economic extravaganza and store owners are rubbing their hands with glee.

A crowded Eldon Square shopping centre, Newcastle, soon after its opening in 1976.

Now some are making efforts to increase staff to cope with the rush:

WH Smith: Takings 100 per cent more than they expected.

Topshop: Takings double what they thought they would get.

Jackson the Tailor: absolutely delighted.

Mothercare: happiest with Newcastle.

Greggs: They had to send for more bread.

Sales at Smith's have reached the 23,000 mark in two days the centre has been opened (and that's 20 per cent more than their shop in Brent Cross, the London shopping complex supposed to be on a winner).

'The Eldon Square store is the third largest in the WH Smith chain and on these figures can expect to net the third largest takings', said manager Joseph Allan. 'We have taken far in excess of what we thought. We have had about, 23,000 sales while twice that number of people must have passed through the place. Our staff did a valiant job although we could have used another twenty on top of the existing eighty.'

The Eldon Square shop has beaten Brent Cross – also newly-opened – in an internal competition for sales organised by Smith's. 'Our first-day takings are higher by 20 per cent,' said Mr Allan.

There is a similar success story at Topshop, the fashion store. The first day's trade was as much as they expected over the first three, said regional manager Vera Birch. 'We are extremely pleased with the good take-off, it's much better than the first days of our similar shop in the Victoria Centre, Nottingham,' she reports. She said takings were double the expected figure – but Topshop had enough assistants to handle the rush.

At Jackson the Tailor, general manager Roger Stallard said, 'If things continue as they have been, we must start to think in terms of a real money winner. I am absolutely

delighted. The staff have been elated and flat-out. The first reaction augurs well for the future of this giant operation.'

A spokesman at Mothercare head office in Watford said that the shop in the Eldon Centre had started well and was delighted with its first-day takings. 'We have opened three shops this week and we are happiest with Newcastle,' she said.

Greggs of Gosforth report that their takings were 'very, very good' and that they had had to send back to the bakery for more bread.

1976: Tragedy at Swan Hunter

The £23 million HMS *Glasgow* was being fitted out at Swan Hunter's Neptune yard when a horrific fire killed eight workers and injured six. A later report confirmed the blaze was started by a welder's torch igniting gas that had been leaking from an oxygen cylinder.

More than 500 men were working on the 3,500-ton destroyer and some had difficulty getting off the ship. The ship was commissioned three years later and took part in the Falklands conflict where it was badly damaged by an Argentine bomb.

After more than twenty-five years of service the vessel was decommissioned in 2005, and finally broken up in 2009.

EIGHT KILLED IN SHIPYARD DISASTER

The Journal, Friday 24 September 1976

Eight men were killed and six injured yesterday in one of Britain's worst shipyard disasters.

The top-secret guided missile destroyer HMS *Glasgow* – one of three ultra-sophisticated Type 42 warships built on the Tyne – was being fitted out at Swan Hunter's Neptune Yard at Walker.

The dead men were working on number three and four decks near the machinery control room, part of which is below the ship's water line. One of them had been married only five weeks and another for elevel months. Shipyard worker Peter Dowey, aged twenty-one, married his eighteen-year-old bride Christine in August and the couple moved into their first home at Cramlington. And workmate Alan Taylor, also twenty-one, of Wallsend, who married late last year and leaves a widow and a baby daughter, was another victim.

Last night, one of the survivors, Douglas Brydon aged thirty-eight, told how he owes his life to his memory, after groping his way to safety in total darkness as choking

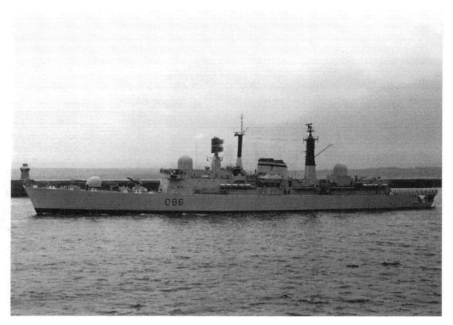

HMS *Glasgow* leaves the Tyne in March 1979. Eight workers died in 1976 during the destroyer's construction.

fumes swept through the ship. He said, 'Every time I go on a new ship, I memorise the way out. It's a thing you do when you are working in confined spaces. That's what saved me.'

Mr Brydon, father of a five-year-old son, of Fairhaven Avenue, Walker, Newcastle, was working three decks down when the lights went out and silence fell. He said there was no explosion.

Coughing

'We are supposed to stay where we are when the lights go out. But I decided to get out.' On the way, he heard a workmate coughing, but could not find him. He climbed two ladders and 'when I reached the top, I thought I had won the pools.' After treatment at the shipyard ambulance station, Mr Brydon went home, but said he would be ready for work today.

The disaster happened just after the morning shift clocked on for work at about 7.30 a.m. The first hint of horror came when a Swan Hunter security guard spotted smoke billowing from the forward part of the 3,500- ton destroyer.

The shipyard's own fire-fighting force were drafted to the scene, but were beaten back by dense smoke. They alerted the 900 shipyard workers fitting out the £23 million vessel as units from the Tyne Wear brigade arrived. The shipyard workers had to battle their way to, and then down, a single five-foot wide gangplank to reach safety on the quayside.

Tyne Wear brigade divisional commander, Norman Dodd, who led the fire-fighting operation, said, 'Conditions were grim. My men had to find their way around inside by touch.'

Body

The first body, found by firemen after about fifteen minutes, was lying in a compartment on number four deck. The remaining dead were discovered in compartments scattered about the lower decks. Last night police had still not identified three badly-charred bodies.

The fire, which ripped through electric cables and glass-fibre insulating material, was brought under control after about two hours. But the area was not sealed off as fire chiefs feared other men may have been trapped in pockets deep inside the vessel.

About two hours after the blaze started, Swan Hunter officials carried out a roll call of workers in an attempt to find who was missing. The men were also asked to drop their cards in a special box at the Neptune Yard gates to double-check the casualty figures. Worried wives gathered round the gates and one was escorted away by the police in tears.

Shock

One of the injured men, Mr Edward Townsley, was plucked from one of the compartments by firemen and taken to Newcastle's Royal Victoria Infirmary after being overcome by fumes. Three workers were treated for shock at the yard's own casualty department and two firemen were taken to hospital – one after being overcome by the choking smoke and the other suffering from burns. One of the men working on the ship, thirty-three-year-old Mr Bill Gibson, said he had been on number three deck about twenty minutes before the blaze. He had gone back to the ship with firemen to install ventilators to clear the smoke.

Mr Gibson, of King Street, Pelaw, said, 'It was pure hell down there. It is gutted inside, with water and burnt-out cables everywhere. I would not have fancied going down there.'

Another worker, Mr Robert Lapsley, of West Moor, said he was in the engine room when the fire broke out. 'The corridor filled with smoke and the lights went out. It was a bit rough,' he said. 'It is a dangerous part of the ship. Men get extra allowance for working down there.'

The *Glasgow* – the eighth Royal Navy ship to bear the city's name – was launched in April by Lady Treacher, wife of Admiral Sir John Treacher.

At the time of the fire, the ship was tied up immediately behind HMS *Newcastle*, another Type 42 vessel.

The *Glasgow* is one of three Type 42s built by Swans. The third, HMS *Exeter*, is still on the way at the Neptune Yard. A fourth, HMS *Cardiff*, is in the river for fitting out after being built by Vickers at Barrow.

1977: Hello, Mr President

The visit to Tyneside by American President Jimmy Carter in May 1977, is still fondly remembered decades later. The so-called 'peanut farmer from Georgia' had recently taken office and this was his first foreign visit. More than 20,000 onlookers cheered when he uttered the words 'Howay the Lads', on the steps of Newcastle Civic Centre.

In 1988, he returned to celebrate a decade of his Friendship Force project. The first exchange had involved 762 travellers from Newcastle and Atlanta, Georgia.

The lucky folk involved would stay in each other's homes, experience each other's jobs, and learn about life in a foreign country.

Evening Chronicle, Friday 6 May 1977

INCREDIBLE WELCOME FOR THE PRESIDENT
'Howay the Lads' he tells 20,000 Cheering Fans

Seldom can an American president visiting this country have received the kind of welcome that Jimmy Carter got when he stepped off the plane at Newcastle Airport today.

The President chose to come to the north east as part of his first overseas visit since taking office, and Tynesiders showed how they felt about the decision. They packed the airport. They packed the streets. They packed the area outside the Civic Centre and they opened their arms to him.

And he loved it. A great smile spread across his face at the airport as he was greeted by crowds waving both the Union Jack and the Stars and Stripes. People had been waiting since daybreak and they were not disappointed for the smile made it all worthwhile.

The President was greeted by the Lord Lieutenant, the Prime Minister James Callaghan, and various local dignitaries, before he and the Prime Minister entered a Daimler car.

A cavalcade of sixteen cars packed with security men, aides, and press men started to move, but suddenly there was consternation as the cars stopped. Nobody knew what was happening.

Security and photographers moved in, but the alarm was soon over.

It was the President making sure that his wish to meet the people was coming true. He had stopped to shake somebody's hand. When the President arrived in the city centre, the roads were jammed with people, many of them children.

President Carter left his car and immediately plunged into the crowd, smiling and shaking hands with many people, from policemen to children. Many reached forward just to touch him.

As the Lord Mayor welcomed him, a tremendous cheer went up. The Lord Mayor, Cull Hugh White greeting the President said, 'The people of Newcastle upon Tyne today welcome you as the President of the United States, as head of a country that, despite its comparative youth, already has long associations with this country. We are, of course, delighted that your first visit abroad since assuming office is to Newcastle, albeit that you decided to make a short stop overnight in some other city.

We hope that you will enjoy your visit to the north east with our Prime Minister, and hope that your discussions will be fruitful and of benefit to all the nations of the world. The people of Newcastle have another reason to welcome the President here today. We are pleased that Newcastle and Atlanta, the capital of your home state of Georgia, will be the first cities in the world to exchange ambassadors at

the beginning of your Friendship Force programme. We believe that this will be another great event in our history, and you will see that from the welcome you have received today.

Finally, in our long history we have had many Freemen of the City. It is my privilege on behalf of the City Council and the citizens of this ancient city to invite you to accept the honorary Freedom of Newcastle upon Tyne.'

Mr Carter began his short speech by simply smiling and saying 'howay the lads' in an almost perfect Tyneside accent. More than 20,000 Geordies stamped, whistled and roared their approval.

Clearly touched, the President told the crowd, 'I am very grateful to be a Geordie now.' Later, Mr Carter and his wife Rosalynn were whisked off to Washington Old Hall, the ancestral home of America's first President.

1977: Queen's Silver Jubilee

The silver jubilee of Queen Elizabeth II in 1977 was proof of the enduring popularity of the monarchy in Britain.

There were street parties and celebrations across the land, and schoolchildren were given commemorative mugs and coins. During the summer months, the Queen and Prince Philip embarked on a mammoth tour of the country, visiting thirty-six counties across the UK and Northern Ireland.

On 15 July, the north east afforded the Royal couple a rapturous reception. Thousands cheered as the Royal Yacht Britannia sailed into Newcastle Quayside – and thousands more lined the streets as the Queen's limousine wound its way to South Shields and Sunderland.

Evening Chronicle, Friday 15 July 1977

QUEEN OF THE TYNE
Britannia Rules the Geordie Waves

The Queen and Prince Philip received a tumultuous Geordie welcome from the people of Tyne and Wear today.

Wherever they went, the story was the same – thousands of people shoulder to shoulder wanting a chance to see the royal couple. At every stop along the sixty-four-mile route, huge crowds, cheering and waving Union Jacks, were there to greet them. It was the second time this year the region was able to demonstrate the

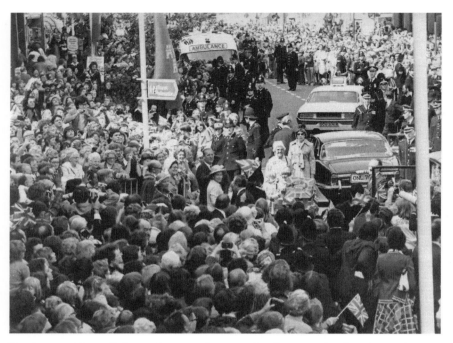

The Queen and Prince Philip are the centre of attention for a huge crowd at Eldon Square shopping centre, Newcastle, during the Silver Jubilee tour of 1977.

warmth of a mass Geordie welcome. And if the turn-out for President Carter in May was impressive, today's welcome for 'wor Queen' was even more spectacular.

From first thing today when the Britannia nosed into the Tyne, thousands had already picked vantage points along the route which took the royal couple from Newcastle to South Shields, then to Sunderland and Washington before lunch. But for the crowds lining both banks of the Tyne, Britannia's journey to Newcastle Quayside was a bit of a let-down.

Neither the Queen nor Prince Philip could be seen on board, although waving hands could be seen behind the yacht's windows.

As the Britannia slid into berth at Newcastle, the band of the Royal Marines on board played 'Keep Your Feet Still, Geordie Hinny'.

And when the Royal couple set foot on Geordie soil the waiting thousands went wild. Thousands were at the Quayside, and hundreds more lined the Tyne Bridge – in spite of official police directions that the bridge should not be used as a vantage point.

aBy the time the Royal motorcade arrived at the next stop – the Sunderland shipyard of Austin and Pickersgill – it was more than half-an-hour behind schedule. The Queen's visit had brought production at the yard to a halt for two hours, but the procession of cars took just two minutes to pass through the Southwick Yard without stopping. Then the royal couple made straight for the Washington Wildfowl Park. By this time the cavalcade was forty minutes late. But, ten minutes of this had been made up by the next stop – Washington Sports Arena. Here, too, a huge crowd was waiting to greet the Queen.

Several times during the tour the Queen stopped her car to accept flowers from youngsters.

As she passed through Seaburn it was a great day for one youngster in a wheelchair. The Queen, seeing him carrying a bouquet, asked her driver to stop. The young boy's parents pushed the wheelchair towards the royal car and he handed the flowers to the Queen.

She stopped the car again at Sunderland to accept flowers from two small girls. And while she was travelling through the town many people dashed in front of the car to the other side of the road to get a better view.

It happened so suddenly that police were taken unawares.

The whole route was chequered with flags and home-made banners proclaiming: 'Howay the Queen' and 'Welcome Liz'.

Every conceivable vantage point had been taken over – many people perched precariously on roofs and one man stood on the top of Cornings glass factory In Sunderland.

1977: 'The Greatest'

In 1977, world heavyweight boxing champion Muhammad Ali was probably the most famous man on the planet.

His most unlikely visit to Tyneside in the balmy summer of that year was the brainchild of painter and decorator, Johnny Walker. Amazingly, Ali accepted Johnny's audacious request to fly from America to the north east of England to help raise money for local sporting clubs.

Tens of thousands turned out as 'The Greatest' toured the region in an open-topped bus. Ali even had his recent marriage blessed in a South Shields mosque. He was moved to say, 'I've never been so honoured – not even in America itself by Government officials and authority.'

Evening Chronicle, Saturday 16 July 1977

NICE ONE, ALI

Muhammad Ali continued his own royal tour of Tyneside today with visits to Newcastle and South Shields, having clowned, laughed and cuddled his way into the hearts of hundreds of handicapped children at Pendower School.

The ever-exuberant Ali made everyone happy and relaxed.

Dressed in a beautifully cut brown striped suit with a waistcoat – because he thought it was so cold – he stood among the children and said, 'I am happy and proud to be in

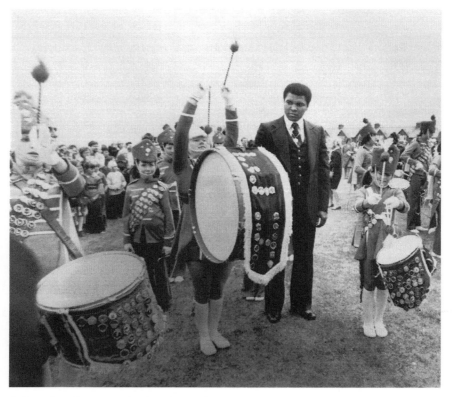

Embassy Heralds Jazz Band and Muhammad Ali on his visit to Tyneside in July 1977.

Newcastle to help raise money for boys' clubs. I have been in London about five times but never heard of Newcastle till now.'

Mock groans of dismay. Then the champion went on to say it meant more to him to come to the school, in the West End of Newcastle, than anywhere else, because the children could never come to see him. 'It touches me,' he said. 'I guess I'll go back home and have two more fights at the most. I'm getting too old now.'

Groans of protest, this time genuine. Ali then presented seven-year-old Angela Davies with a standing frame designed and made for her by apprentices at the Fellside Engineering Training Association with the help of Vickers trainees.

Angela is a victim of a rare disease that means she must wear callipers from foot to chin and has little or no power in her arms and legs. Ali lifted and cuddled her, then installed her in the frame.

Another pupil, Stuart Burns, of Dolphin Street, Benwell, read him a poem composed by himself and some other boys, then he had a mock boxing match with Ali. It ended with the champion falling to the floor and congratulating Stuart. 'You are the greatest,' he told him.

Ali was mobbed at a charity event in South Shields today.

Crowds burst through barriers and rushed towards Ali's open-top bus as he arrived at Gypsies Green stadium.

Then he was able to start a charity match against dart champion Alan Evans. The St John Ambulance Brigade treated about a dozen people for sprains and cuts.

One woman had to be taken to hospital when she fainted and was crushed.

1980: Ticket to Ride

It's taken for granted now, but the Tyneside Metro revolutionised commuter travel when its first passengers boarded in 1980.

The system, first envisioned and mooted in 1973, would cut out the bulk of the traffic gridlock that was increasingly hampering access to Newcastle city centre and, indeed, facilitate easier passenger travel across the region.

The first Metro trams were banana yellow, echoing the livery that had adorned local bus services for years.

It wasn't until November 1981 that the system was extended south across the river, but only to Heworth, and it was not until March 1984 that the line would continue to South Shields.

It was further extended to Sunderland in 2002.

Evening Chronicle, Monday 11 August 1980

READY, STEADY GO

Thousands of Tyneside commuters travelled to work for the first time today aboard the area's new £278 million rapid transit system, the Metro.

The journey seems to have gone quickly and smoothly for most travellers, though there were some teething troubles as transport chiefs had warned. The first train, the 5.31 a.m. from Tynemouth to Haymarket, was about ten minutes late leaving.

Railway enthusiasts mingled with early-morning workers aboard the train, and the first ticket was bought by nine-year-old Angus Parr, of Aberdeen, who had travelled to Tyneside for the occasion.

The 8.21 a.m. also failed to turn up at Tynemouth and passengers were held up for twenty minutes, arriving at the Haymarket at 9.07 a.m. instead of 8.47 a.m.

The 7.51 a.m. from Tynemouth was about five minutes late and the driver used the public address system to apologise to passengers for the delay, due to signals at South Gosforth. There were also some minor problems with the ticket machines and barrier equipment. Some passengers at Tynemouth found that the barriers would not move when they had put their tickets in.

Tyneside's Metro passengers stepped on to the first trains in August 1980.

There was the same problem at Haymarket, where French maintenance men installed replacement circuits in barriers that would not move. Some passengers had difficulty opening the metro doors, finding that the green buttons had to be pushed quite firmly. Some passengers missed their train at Ilford Road when it left about four minutes early and the 7.02 a.m. became the 6.58 a.m. At Four Lane Ends interchange an automatic fire alarm malfunctioned and a fire engine was called.

Although thousands of passengers used the Metro today, most found that it was far from overcrowded.

Meanwhile, thousands of Tyneside travellers switched from trains to buses. The southern section of the North Tyne loop line was closed to coincide with the Metro opening. Rail-link buses took over from the local trains between Newcastle and Tynemouth via Wallsend.

The change-over appeared to go smoothly, in spite of concern in recent weeks that agreement on the service would not be reached in time between the Passenger Transport Executive and the busmen.

Work will now start on electrification of the line, which should re-open as part of the Metro in about eighteen months.

Senior officials of the PTE were today travelling around the system to see how it was working and were not immediately available to comment on the teething problems.

Evening Chronicle reporters travelled on the Metro this morning and reported things were running relatively smoothly.

1981: Great North Run

It's a north east institution. An event requiring stamina, determination, and a modicum of running ability.

The first Great North Run between Newcastle and South Shields took place in June 1981.

Tyneside's very own half-marathon was devised by former schoolteacher and Olympic 10,000m bronze medallist, Brendan Foster.

Hebburn-born Foster – today a respected television sports pundit – was inspired to put together the Great North Run after competing in the Round the Bays Race in New Zealand in 1979. By 2014, the number of participants had risen to 57,000. Back in 1981 it was advertised as a local fun run.

Today, it is one of the biggest running events in the world, with millions raised for charities by competitors, and with countless famous names taking part.

The Journal, Monday 29 June 1981

WHAT A RUNAWAY RECORD BREAKER
Charities are Big Winners as 10,665 Finish Race

The Great North Run was a record-breaking success yesterday, and last night the organisers were predicting an even bigger and better event next year.

Crowds estimated at between 250,000 and 500,000 turned out to watch the 12,264 runners on the race route from Newcastle to South Shields seafront, making it Britain's biggest road run.

It is also expected to set a series of other records, including the most money raised for charity by sponsorship.

Up to £1 million could be going to charities with the Charlie Bear Scanner Fund – backed by *The Journal*, *Evening Chronicle*, and *Sunday Sun* – one of the biggest beneficiaries. An amazing 10,665 runners crossed the finishing line to collect their race medals.

Brendan Foster, one of the organisers, said last night, 'It's been a great day for the region, and a privilege to be there. We have got no choice. We'll have to have another one next year.'

The winner was Elswick Harrier Mike McLeod in sixty-three minutes, with Foster finishing 20th.

Ambulancemen had a hectic time as around thirty people were taken to the Ingham Infirmary, South Shields. There were no serious medical emergencies during the race, although four runners were detained last night in two Tyneside hospitals with exhaustion.

Three were kept in the Ingham Infirmary and the fourth in Newcastle General Hospital. Staff said all were comfortable.

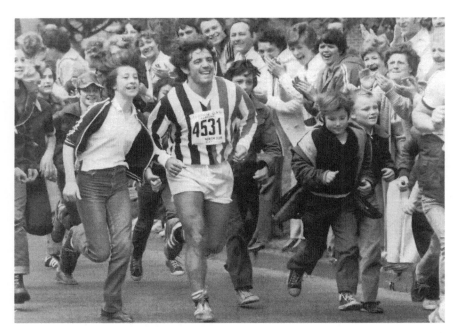

Kevin Keegan, future Newcastle United player and manager, takes part in the first Great North Run, 1981.

Footballer Kevin Keegan who ran for the Charlie Bear Appeal said, 'The people up here have been wonderful to me, but the person I really did it for was Charlie Bear. I'm just glad to be able to help such a good cause. Running in this race means I am helping people with cancer and that can only be good,' said Kevin, who finished 490th.

The run cost him about £250. Kevin had promised to pay 50pence towards the body scanner for every man, and £1 for every woman who beat him. Sixteen people in wheelchairs also took part and the crowd was staggered by the performance of twenty-six-year-old Alan Robinson.

He set off about five minutes before the leaders and finished 652nd in a time of one hour twenty-eight minutes fifty-four sec. Newcastle University law student Nicholas Mack ran the race of life, and ended up in hospital as one of the casualties. Nicholas ran the first 10 miles in seventy-five minutes but the last three miles proved too much for the twenty-year-old.

'They were the longest 3 miles I had ever run. I thought I was doing great when the heat just got too much. I think I was dehydrated.' Nicholas made it to the finishing line. When he woke up in a Red Cross tent, he had his medal around his neck.

'I can't remember finishing. Everyone was passing me and I felt dizzy. It was just like running on the spot.'

Mrs Margaret Preece of Northumbria Red Cross said, 'We had to call in the county ambulance service when things got very hectic.'

1983: Diana Thrills the Crowds

In the years before marital woe, lurid newspaper headlines and, ultimately, tragedy, Princess Diana was the smiling, fresh-faced new superstar of the royal family.

In May 1983, less than two years on from her marriage to Prince Charles, Diana was on Tyneside for a day of engagements. Officially opening the new Redheugh Bridge, Diana became the fifth member of the Royal Family since 1845 to open a bridge across the Tyne.

On a dull, overcast day, thousands turned out to see her. It was a day which also saw the Princess open the new £30 million Findus factory at Longbenton.

It's not reported if she tucked into Findus Crispy Pancakes!

Evening Chronicle, Wednesday 18 May 1983

DIANA IS OUR DARLING
Crowds Flock to see the Fairytale Princess. Sparkling Smiles for the Crowds.

Princess Diana warmed the hearts of thousands of Geordies when she opened the new Redheugh Bridge this afternoon.

She arrived on a plane of the Queen's Flight looking radiant in a blue velvet suit and matching sparkling earrings. She was greeted by gasps of appreciation as she stepped daintily down the stairway and gave a beaming smile to the photographers clamouring for shots of the tanned Princess.

Her outfit of tailored blue velvet toned perfectly with maroon clutch bag and maroon and gold-toned flat shoes. The Princess was wearing her famous sapphire and diamond earrings which set off the whole outfit. That famous Princess Diana waistline was emphasised by the short fitting jacket and the longer length velvet skirt.

Children catching a glimpse of the Princess waved and cheered, shouting, 'Diana, Diana.' She was asked by the civic dignitaries how she was feeling. She replied 'marvellous'.

Eager

The crowd were eager to catch a glimpse of that Diana smile and she returned their patient loyalty in waiting for the flight by waving, especially to the children of Dinnington Village First School, who had a prime position at the front of the exit road from the terminus building.

The Princess held her head high for the youngsters to get a good view.

Overcast skies and a threatened downpour did nothing to dampen the spirits of thousands of people who turned out to welcome the Princess to Longbenton.

From tiny tots to grandparents, they lined the route to be taken by the Princess who was opening the £30 million Findus factory at Longbenton. There were crowds outside Four Lane Ends Metro Station and the road from there to the factory was a sea of red, white and blue.

Thousands of people outside the gateway to Findus were kept back by police.

The crowds thronging the Redheugh Bridge included children from twenty schools and ninety disabled, some from Pendower Special School.

Some spectators, including women with babies, had taken up position three hours before. A forest of hands was in evidence to wave Union Jacks.

Among the party from Age Concern at Newcastle Airport this afternoon were ninety-year-old Miss Mabel Burgess and her eighty-six-year-old sister Miss Lillian Burgess. Lillian, who lives with her sister at Cruddas Park in Newcastle, said, 'I'm absolutely thrilled at being here today. When I used to live in London I watched the changing of the guard and every royal event I possibly could get to see. I remember the days of Queen Mary and when the royal children used to play in the park when they lived in Piccadilly. But today is a thrill of a lifetime for me. My sister Mabel and I don't get about as often as we'd like to and to see Princess Diana is something really special. She's a lovely member of the Royal family and she has special qualities. Enough to bring me out just to wave and see her smile.'

Ninety-year-old Mabel was in her wheelchair at the airport but she said she was determined to be there to wave and cheer with the crowds. Mrs Hilda Donnison, sixty-eight, of Monday Crescent, Fenham, said she thought Diana was 'perfectly natural' and the best advertisement for royalty in the world.

1983: *Auf Wiedersehen, Pet*

When *Auf Wiedersehen, Pet* first aired on ITV in November 1983, the series proved to be an instant television hit.

Set at a time when unemployment was rising, it focused on seven ill-matched British tradesmen in search of work who'd been thrown together on a German building site.

Written by famed writers Ian La Frenais and Dick Clement, the drama-comedy made stars out of the largely unknown cast. Indeed, the Geordie trio of Tim Healy, Jimmy Nail and Kevin Whatley would all become household names.

Auf Wiedersehen, Pet boasted superb scripts and memorable acting performances.

There would be three subsequent series and a farewell two-part special before the lads finally bowed out in 2004.

The Journal, Friday 11 November 1983

MEET THE GEORDIE MAFIA

They call them the Geordie Mafia. That collection of often unlikely actors who have their roots in the north east and whose entry into the world of theatre and television is sometimes by a decidedly unconventional route.

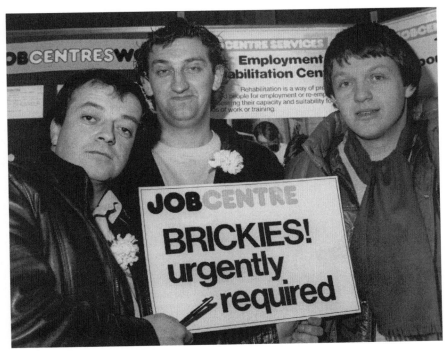

The Geordie stars of *Auf Wiedersehen, Pet* – Tim Healy, Jimmy Nail and Kevin Whatley – at a Newcastle job centre in 1983.

Experienced directors and producers know that the chance of finding an actor from elsewhere who is capable of reproducing an authentic Geordie accent is slim. Even the late Joyce Grenfell confessed the accent had defeated her.

So when Central Television went looking for people to play the three leading roles in Auf Wiedersehen, Pet it is hardly surprising that their casting directors should choose to spend some time in Newcastle, as well as holding auditions in London.

The action centres on the adventures of three building workers from the north east who leave behind their beloved region in search of work in Germany. And since it has been written, mostly, by Dick Clement and Ian La Frenais – responsible for such sparkling television successes as *The Likely lads* and *Porridge* – it is not unreasonable that it should be given peak-time screening on Friday nights.

The visit to Newcastle paid rich dividends for the Central TV team. They 'discovered' Jimmy Nail whose only previous connection with the entertainment business was as a singer in a heavy rock band.

Jimmy, who is the brother of Newcastle actress Val McLane, plays Oz Osborne an irresponsible character who welcomes the German jaunt as a chance to escape from his wife. Tim Healy who has worked with Live Theatre in Newcastle and as a stand-up comic was last seen on television as the aggressive full-back Dirty Hoggie in the Tyne Tees production of *The World Cup – A Captain's Tale*.

Here he plays Dennis Patterson, the reluctant leader of the group - a man who is having trouble in facing up to an inevitable divorce.

The third member of the team, Neville Hope, is a serious young man who is forever writing to his wife and sending back money towards a down-payment on a home of their own. And the role goes to north-easterner Kevin Whatley.

Kevin though will not be able to watch himself on the box tonight. He'll be on stage at Newcastle Playhouse answering the very different demands presented by the part of Hal in *Henry IV Part One*.

After that run ends next month, though, he will put his feet up and relax at home for Christmas. 'It will be the first real break I've had for two years,' he says. In fact, Kevin has rarely been out of work since he gave up an accountancy career to go to drama school eleven years ago.

He had a year of his articles to complete when he quit his job at Price Waterhouse. 'I had to go then,' he says, 'because I was on about £800 a year and if I'd become a chartered accountant my salary would have shot up to £3,000. That would have been difficult to give up.'

He had decided anyway after acting at the People's Theatre in Newcastle for three years that this was the direction he wanted to take. But after a career in rep, on television, and in London with the Prospect Theatre Company – plus the odd engagement back here in Newcastle with the Tyne Wear Theatre Company – *Auf Wiedersehen, Pet* represents probably his biggest break.

It took eleven months to make and was only, in fact, completed in June. 'Each episode is a little play on its own,' he says. 'When we first got the scripts we all had a real buzz. They were certainly the best television scripts I'd ever read. In fact it started out as a drama series but it later tended to develop as a situation comedy and I'm not sure that was a good idea,'

The series was, in fact, the last to be made at Central's Elstree Studios but it also involved location work in Hamburg and Dusseldorf, where the cast were involved in a few adventures. In one scene, actual prostitutes were used as extras 'which was all right', says Kevin, 'until their Teutonic pimps moved in.'

'They were really seedy looking guys with scarred faces and vicious looking dogs.' But worse was to befall Kevin as the filming continued. He jumped off a wall and landed on a steel girder, breaking his ankle in three places. Two days later they were due to do a football scene and he had to be strapped up with special bandage. Plaster was out of the question.

The conversation drifts back to the "Geordie mafia". What exactly is that? 'Well it all stems back to *When the Boat Comes in*. Every Geordie actor that ever was appeared in that,' says Kevin, 'and everybody got to know each other. It became a bit of a legend and directors tend to contact the people behind it every time they want an actor to play a Geordie. I instinctively stayed out of it for a long time and have hardly been asked to use the accent since I left drama school. But the others will tell you, belonging to it has its advantages. The work rolls in.'

For Kevin, Tim Healy and Jimmy Nail, *Auf Wiedersehen Pet* is obviously going to be very important in terms of exposure.

Even the five syllables which spell out the title seem to exude a certain north eastern promise.

1983: *Tuxedo Princess*

For nearly two and half decades the floating nightclub, the *Tuxedo Princess* (and for a while its replacement the *Tuxedo Royale*) attracted clubbers to its familiar spot underneath the Tyne Bridge.

Celebs spotted partying on the revolving dance floor included Mick Hucknall, Frankie Goes to Hollywood, Rick Astley, Nik Kershaw, Noel Edmonds, Freddie Starr, Ian Botham, Kevin Costner and Andrew Lloyd Webber, while local revellers included Gazza, a succession of Newcastle United stars, and the cast from *Auf Wiedersehen, Pet*. Cheryl Tweedy worked there before becoming better known as the pop sensation Cheryl Fernandez-Versini.

Opened in 1983, the 1961-built former car ferry was a magnet for revellers until its slow decline and closure in 2007.

Evening Chronicle, Monday 19 December 1983

PLUSH NEW LOOK FOR OLD FERRY

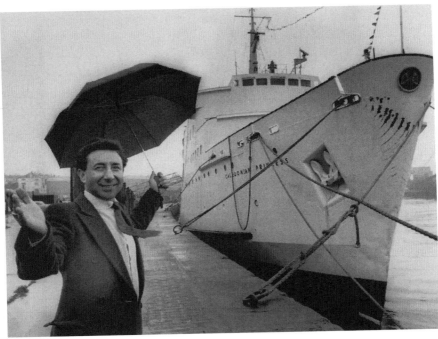

Nightclub owner Michael Quadrini welcomes the arrival of his new floating nightclub the *Tuxedo Princess* on to the River Tyne, 2 March 1983.

A £1 million dream will come true for nightclub owner Michael Quadrini when the elegant *Tuxedo Princess* 'weighs anchor' tomorrow night.

Five months non-stop work has seen the *Caledonian Princess* converted from a hard-working ferry boat to a luxurious floating leisure complex.

Renamed the *Tuxedo Princess*, the ship is now moored – although she is still seaworthy – to the Quayside on the Gateshead side of the Tyne underneath the impressive Tyne Bridge. But people who might have travelled on her in earlier days wouldn't recognise her now.

Coffee bars have been transformed into elegantly decorated cocktail bars serving exotic concoctions from around the world, cafeterias have become attractive restaurants, the dreary television lounge is now unrecognisable as the lavishly furnished nightclub and disco. *The Princess* is the fulfilment of a long-standing ambition for Michael Quadrini, who pioneered luxury nightlife in the north when he opened Tuxedo Junction in Newcastle city centre six years ago.

'He's always had a dream of owning a floating leisure complex,' said a spokesman. 'Then he got the opportunity to buy this ship. He's lived with this project for almost the whole of the past year. When the ship was berthed in the Tyne in July we were able to start work, and it has taken five months to get the first phase ready for this Christmas opening.'

But now the *Tuxedo Princess* is ready, in all her glory, to welcome the first revellers.

Walk up the ramps from the Quayside car parks, and leave the cold, grey north east behind! Enter a world of warmth and luxury, with striking decor designed by Michael Quadrini. There are specially woven carpets for the floors, fabric wallcoverings in dramatic diagonal stripe with the design linked throughout the main level, but the colours changing in different areas.

In Di Angelo's Pizzeria for example, green and cream stripes are the order of the day, giving a marvellously fresh feel, coupled with the hundreds of plants (real and silk) that are stacked around the walls, plus beautifully ornate art deco lamps.

Stripes in Diane's Discotheque are grey, black and pink. Michael promises the best sounds around, with chief DJ being the famous Big Phil, who's already proved so popular at Tuxedo Junction.

Through another reception area you'll find the Cunard Cocktail bar, with the decor in cream and fuchsia pink. Dominating the bar is an impressive mirror with a neon replica of the *Tuxedo Princess* illuminating it.

The Cunard bar opens out on to the ship's foredeck, which will be decked out with tables when the weather gets a bit warmer. And this bar's speciality will be a wide and exotic range of cocktails, plus some unusual imported beers. A full choice of wines and champagnes is available throughout the ship's bars.

What the first customers will see on Tuesday evening is impressive enough, but that's just the beginning. By the end of next year the Tuxedo Princess will contain eight bars, each with different themes, a more formal restaurant as well as the pizzeria, and a barbecue deck with its own swimming pool.

The ship's seventy cabins will be converted into forty-five luxurious and spacious hotel bedrooms, and the lower deck (where the cars used to be) will become a function suite and conference centre for up to 300 delegates.

The Tuxedo Princess was previously known as the *Caledonian Princess*, and was built as a replacement for the *Princess Margaret*, which sank in 1954. She was the last steam turbine ferry ever built.

She is more than 4,000 tonnes, and almost 400 feet long, with five decks. As the *Caledonian Princess*, she carried up to 1,300 passengers regularly on many of the cross-channel and Irish Sea routes. And she is, incidentally, still seaworthy, and although her engines are not in working order at the moment, generates all her own electricity for heating and lighting.

1985: Live Aid

Most of the western world stopped for Live Aid on 13 July 1985. The dual pop concert at London's Wembley Stadium and the JFK Stadium in Philadelphia, United States, was watched live on television by nearly two billion people across 150 countries.

The brainchild of pop star Bob Geldof, the charity effort came in the wake of the 1984 Band Aid single, 'Do They Know It's Christmas?' The record and concerts raised millions towards easing the effects of a disastrous famine in Ethiopia.

Folk across the north east watched the 'global jukebox' on television, and many travelled to the show in London. Some of the biggest pop acts in the world – including Geordie stars Sting and Mark Knopfler – performed on that memorable day.

The Journal, Monday 15 July 1985

BUS DRIVER'S AID SOLVES TICKET POSER

Two north-east music lovers missed the bus to see their Live Aid heroes at Wembley – and another hero saved the day.

Mandy Gray, nineteen, and her twenty-year-old friend Helen Nicholson overslept and missed the coach, but then a good samaritan stepped in.

United Buses driver Alan Rouse was the girls' hero after a frantic dash round the capital's West End in search of a colleague who had their concert tickets.

Mandy, a children's nurse at Sloan Row, Grange Villas, Chester-le-Street, said the £40 National Express all-in trip from Durham meant picking up the entrance tickets with the driver.

The girls woke up only five minutes before the coach's 5.00 a.m. departure, and raced to London on the train instead hoping they could track down the driver. At Wembley he was nowhere to be seen as Mr Rouse stepped in to aid the tearful girls.

Fans queue at Newcastle City Hall to buy tickets for the giant Live Aid concert at Wembley Stadium in July 1985.

Mandy said, 'He drove us in his coach to where all the drivers go.' After an unsuccessful search of the bus station canteen and all the Victoria pubs used by the National Express men, the driver was found in a nearby hotel. He was having his afternoon nap before the return journey.

Tickets in hand, Mandy and Helen dashed to the nearest Tube station and arrived only an hour late. 'We're going to write to Mr Rouse's depot in Middlesbrough saying how great he was," said Mandy. Without him we'd never have got to the concert.'

Mandy said two alarm clocks failing to go off had caused the problem for her and Helen, a coach company employee. Mr Rouse, thirty-two, who had driven another party from the north east said the day was eventful.

He had already had to deal with one tearful girl who had just lost her ticket down the toilet of a motorway service station.

1986: Queen Rock St James' Park

The flamboyant rock band Queen had played in the north east on many occasions in the 1970s. The biggest and best show Freddie Mercury and the boys delivered in the region however, took place in the summer of 1986.

They arrived at St James' Park, Newcastle, on 9 July as the biggest band in the world – on the back of their triumphant appearance at the previous year's Live Aid concert at Wembley Stadium.

Freddie and the boys rocked the home of Newcastle United to its foundations. The *Evening Chronicle* saw fit to publish a special souvenir edition, priced 20pence, for that night's show which was a 38,000 sell-out.

Evening Chronicle, Thursday 10 July 1986

MAGIC SHOW
Queen at St James' Park

There was a kind of magic in the air last night and it was no wonder there was a cheer when Freddie Mercury categorically denied rumours of a Queen split

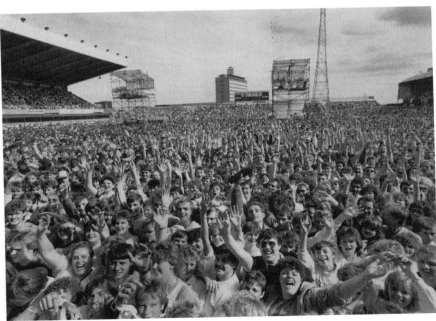

A massive audience filled St James' Park, Newcastle, to watch the rock band Queen on 9 July 1986.

'After all, we're not bad for four tired old queens?' he quipped. Not bad at all, as 38,000 witnesses will testify to this confident demonstration of rock extravaganza.

Freddie used the full, massive width and all levels of the huge stage, as he pouted, cavorted, twirled and paraded peacock-fashion as he sang.

His magnetism seemed to fill the arena, matched only by the musical talents of his cohorts: flailing drummer Roger Taylor, nimble-fingered guitarist Brian May, and quiet but steady bassist John Deacon.

Queen's secret is marrying their visual art and musical skills with instantly appealing anthem-like tunes which linger in the mind – whether it's the very early 'Seven Seas Of Rhye' to set everyone pogoing to the rhythm, or the latest 'Friends Will Be Friends' to spark a sea of waving arms and bodies.

Along the way there was romance and drama aplenty, from the opening number 'One Vision', through the likes of 'Under Pressure', 'I Want To Break Free', 'Love Of My Life', 'Radio Ga Ga', and 'We Will Rock You', to the inevitable 'We Are The Champions'. They even took time out for a series of simple renditions of old rock'n'roll favourites – Elvis Presley's 'Baby I Don't Care', Ricky Nelson's 'Hello Mary Lou', and Little Richard's 'Tutti Frutti' – before taking up the almost operatic strains of 'Bohemian Rhapsody'.

A heart-warming touch was their dedication of the performance of 'Is this the World we Created' – complete with four giant torches lit high above the stage – to the Save The Children Fund, to which the proceedings of the concert are going.

Status Quo lived up to their name, proving that a lay-off and major line-up change have not affected their ability to entertain one iota.

With old stalwarts Francis Rossi and Rick Parfitt, the choreographed guitar twins to the fore, there was hardly any noticeable difference. All the old sense of fun – heavy metal with a grin – is there as they belt out hits like 'Whatever You Want', 'Paper Plane', 'Roll Over Lay Down', 'Rockin' All Over The World', 'Sweet Caroline', and surely the misnomer of all time, 'Down Down'.

German Band Zeno though were rather less individualistic than on record, more bash and thrash metal than the deft touches shown in their album. They seemed to be struggling to fill the stage with their presence, and their sound lacked clarity.

The big disappointment, apart from Brian May's crushingly boring and pointless guitar solo, was the non-appearance of Australian band INXS. Their recordings are packed with promise and, especially after their recent Whistle Test TV spot, many in the crowd were looking forward to seeing them.

Unfortunately, their gear – flown over especially from Milwaukee USA – was stuck in a giant traffic jam on the A1.

1987: A Medical Miracle

Since 1985, an astonishing 2,000 heart and lung transplants have been carried out at Newcastle's Freeman Hospital, on both children and adults.

The hospital's first heart transplant was performed in May 1985 by Mr Christopher McGregor on Gateshead mum-of-two Pauline Duffy, who went on to live another twenty-five years. The Freeman was also responsible for the first successful single lung transplant in Europe.

The *Chronicle* played an instrumental role along the way, setting up Operation Heartbeat, a campaign which helped fund further transplants. Most notably, it was five-month-old Kaylee Davidson who underwent the first successful baby heart transplant.

This triumph of modern medicine hit the headlines in 1987.

The Journal, Tuesday 27 October 1987

HEART-SWAP SURGEON'S HOPES FOR BABY KAYLEE

As the parents of heart-swap baby Kaylee Davidson cuddled their daughter in her isolation cubicle at Newcastle's Freeman Hospital yesterday, transplant surgeon Mr Christopher McGregor spoke of his hopes for her long-term survival.

'She has a long way to go,' he warned. 'But we have no reason to think she won't survive as long as an adult. Some heart transplant patients have lived for seventeen or eighteen years. Research is continuing all the time and children should be able to benefit from that. There is no reason why young heart transplant patients shouldn't live for decades, and there is always a possibility of re-transplanting at ten years or twenty years if necessary.

'Kaylee's life will not be normal, in the sense that she will always require medication. But, apart from that, she should grow up to be an ordinary child attending nursery and school like everyone else.'

Mr McGregor's comments came as Kaylee's parents, Mr Mark Davidson and his wife, Carol, of Oxclose, Washington, told of how their happy, healthy baby suddenly developed the wasting disease cardiomyopathy, which attacks the heart muscles.

'It began in the middle of August when she was three months old,' Mrs Davidson said. 'She became breathless and wouldn't take her feed. She had no interest in her toys any more. She just seemed to change.'

The couple took their baby to a local doctor and were eventually referred to a cardiologist. In a short time, Kaylee was so ill she had to be admitted to the Freeman Hospital's intensive care unit. It was as she lay there clinging to life that the possibility of a transplant was raised. 'We were told she could have a transplant, and a chance of life, or that she would die,' Mr Davidson said. 'Who are we to deny her that chance of life? We decided to go ahead when a donor heart became available, even though we felt that she might not live through the operation.'

Baby Kaylee Davidson, with mum Carol, ten days after her heart transplant in 1987.

Now the Davidsons have been told Kaylee may be home with them in time for Christmas.

'I've been told to take one day at a time, and that's what I'm trying to do,' said Mrs Davidson. 'I'm a little bit worried at the thought of taking her home, but I know the doctors and nurses will be there to help.' The couple said they had not met the family of the donor baby, but were very grateful to them for saving Kaylee's life. 'The family have our deepest sympathy,' said Mr Davidson.

Kaylee, who is now nearly six months old and weighs five-and-a-half lb, has become Britain's youngest surviving heart transplant patient, and prospects for her recovery are now felt to be so good that she may shortly be moved from her cubicle on to an ordinary ward.

Heart transplant baby Kaylee Davidson has established a record as the youngest child in Britain to survive the operation. Now just six months old, she was today playing with her toys in the isolation cubicle at the Freeman Hospital, where she will stay until taken back to her home at Oxclose, Washington, in a few weeks' time.

Transplant co-ordinator Lynne Holt said Kaylee smiled a lot and was very happy. Doctors were pleased with her progress since the operation on 14 October.

Evening Chronicle, Thursday 12 November 1987

TRANSPLANT BABY DOING WELL

Six-month-old Kaylee Davidson, of Washington, has taken her first exercise outside the Freeman Hospital, Newcastle, since her heart transplant operation four weeks ago.

Her mother Carol and father Mark took turns to push her buggy around the grounds. Kaylee, well wrapped up against the cold, laughed and clapped her hands as she was showered with falling leaves.

Transplant co-ordinator Lynne Holt said doctors were pleased with her progress, but it was not expected she could leave the hospital for a few weeks yet.

1991: Riots

Against a backdrop of youth disaffection and alienation, the early 1990s saw riots break out across Britain. Mobs went on the rampage in far-flung locations such as Luton, Bristol and, indeed, Newcastle.

The Tyneside riots erupted on the Meadow Well estate, North Shields, in September 1991 after two local youths died in a stolen car during a police chase.

Copycat disorder soon enveloped Newcastle's West End, as more than 300 rampaging youths threw bricks and fire-bombs at police and emergency services. Masked 'joy-riders' screeched along the streets, burning cars were used as barricades, while shops and schools were looted. The Dodds Arms pub on Elswick Road was burned to the ground as disorder raged.

Evening Chronicle, Thursday 12 September 1991

BLAZING LUNACY
West End a No-Go Area as Battle Raged and Fire Bombs Thrown at Homes

Hundreds of rampaging youths turned Tyneside into a battleground for the third night in succession. Scores of properties including shops, schools, a community centre and a pub were looted and petrol-bombed as angry mobs brought terror to the streets.

Newcastle's West End became a no-go area as police and firemen in riot gear battled to regain control. Two passers-by, two firemen and a policeman were injured and eight people arrested in the violence, which erupted in the Elswick area of Newcastle and rapidly spread to Gateshead and Wallsend.

The Dodds Arms pub ablaze during the Elswick riots of September 1991.

Fire crews and police were out in full force to answer more than 200 emergency calls as the wave of crime escalated. Masked joyriders performed stunts for the crowds as buildings burned in the background in Elswick. Eyewitnesses told how the youths screeched along Elswick Road and burned cars as barricades.

As the tension and violence soared, youths hurled petrol bombs and at the height of the rioting, crews were forced to withdraw from tackling a blaze at the former Dodds Arms pub as a large mob pelted them with bricks.

Violence

Back-up was called in from all over Tyne and Wear, Northumbria and Durham to quell the riots. Police regained control in the early hours as the mob dispersed, leaving a trail of wreckage.

The West End violence follows Monday's riots on Meadow Well housing estate North Shields, after two joyriders died in a blazing car, and disturbances in Scotswood on Tuesday.

Today, Northumbria's Chief Constable Sir Stanley Bailey said the force had reacted immediately to the worsening situation and branded the youths as ignorant and stupid. He blasted the attacks on fire crews and said a small minority of the community was responsible.

'These stupid people who think throwing stones or petrol at firemen is either fun or expressing dissatisfaction at society are both ignorant and stupid,' he said. The inquest on the two joyriders who died in a 125 mph crash in a car they had stolen opens today, and there is a firm police presence in North Shields and Newcastle's West End tonight.

What they said:

'Our tactics were to keep them on the move and protect firemen who went in to quell the blazes. This riot was undoubtedly copycat action by around 300 rampaging youths.' Chief Superintendent Don Wright, Divisional Commander.

'I believe the police did a magnificent job. This sort of behaviour just cannot be tolerated and will not be tolerated.' John Major, Prime Minister.

'My heart goes out to the vast majority of decent people in the area who must be terrified, along with police and fire officers who were placed at risk by the inexcusable mob behaviour.' Jeremy Beecham Council leader.

'Many of the young people involved seem to be so outcast from society, they do not fear detection or punishment.' Doug Henderson MP, Newcastle North – and he called for a visit by the Home Secretary.

1992: Return of King Kevin

When Kevin Keegan arrived at St James' Park in February 1992, he did so as a returning hero.

As a player, King Kev had helped Newcastle United to promotion back to the top flight in 1984. Now, the Magpies were in dire straits and facing relegation to the third division for the first time in their history.

Not only did Keegan save the Toon from the drop, he inspired a football revolution at Gallowgate. Winning promotion back to the top flight, his thrilling, swashbuckling team came within a whisker of delivering United's first league title since 1927.

He returned to St James' briefly in 2008, but walked out after a disagreement with the club's owners.

He remains a football hero on Tyneside.

The Journal: Thursday 6 February 1992

HE'S BACK! KEEGAN TO THE MAGPIES' RESCUE
Ossie Gets the Boot in Dramatic U-Turn by Sir John

Kevin Keegan yesterday moved into the Newcastle United hot-seat and pledged, 'We will turn this club around.'

The former England star was unveiled as the Magpies' new manager following the dramatic sacking of Ossie Ardiles. United chairman Sir John Hall told a packed

Kevin Keegan's first match as manager of Newcastle United. The Magpies beat Bristol City 2-0 at St James' Park on 8 February 1992.

press conference that Ardiles had been dismissed, before adding, 'I would like now to introduce you to the new manager of Newcastle United.'

Sir John, who had repeatedly pledged his backing for Ardiles during a dismal season, explained his sudden U-turn, saying, 'The possibility of Third Division football is disastrous.'

The football knight has put together a £13 million rescue package for the second division club – currently threatened with relegation.

Keegan, taking over team affairs of a club whose debts are spiralling towards the £6 million mark, said the Newcastle United manager's job was the only one in football for which he was prepared to break his retirement. 'I'm fed up of people everywhere I go talking about the Metrocentre,' he said. 'I want them to talk about Newcastle United football club. They don't talk about St George's Docks when they talk about Liverpool, they talk about Liverpool FC or Everton.'

Keegan, forty-one on Valentine's Day, explained he was first approached about the job on Monday by Alastair Wilson, a sales director within the Scottish and Newcastle Breweries Group who had been instrumental in the former England skipper's previous arrival at United almost ten years ago.

Keegan, who has family links with the County Durham pit village of Hetton-le-Hole, met with five United representatives, including Sir John and his son Douglas Hall, at London's Hilton Hotel on Tuesday.

Newcastle Breweries – United's major sponsors – have this time made no special financial input to the deal which, Keegan explained, is yet to be signed although agreement on terms has been reached.

Keegan said, 'We will turn this club around. We have one major plus and that is that we have the best fans in the country.'

1996: *Our Friends in the North*

1996 saw the BBC TV series, *Our Friends in the North*, take the airwaves by storm.

The nine-part saga, which starred relative unknowns Daniel Craig, Christopher Eccleston, Mark Strong and Gina McKee, was set on Tyneside.

The series told of the life journey of four friends from youthful optimism in 1964 to middle-aged cynicism thirty years later, against the backdrop of social and political change in troubled Britain.

The non-Geordie actors perfected their accents by watching old episodes of *Auf Wiedersehen, Pet,* and listening to Bobby Thompson comedy routines. Written by Jarrow-born Peter Flannery, the series made major stars of its four main characters, not least Craig who would go on to play James Bond.

Evening Chronicle, Saturday 13 January 1996

OUR FRIENDS IN THE NORTH HITS THE SCREEN

It's 1964. Harold Wilson is gearing up to win the General Election, the Beatles are big and everyone wants to be a pop star.

The '60s are swinging. It's the dawning of a new age and the dream of Newcastle city Councillor T. Dan Smith to turn Newcastle, riddled as it is with slums and poverty, into the Brasilia of Europe, a city with 'streets in the sky'.

Sadly, the dream turns to ruins with T. Dan brought down in a corruption scandal and the high-rise flats that were his dream turned into concrete monstrosities. Starting on Monday, those days will be relived over nine weeks in the £7 million BBC2 series *Our Friends In The North*. Written by Peter Flannery, it merges fact with fiction, with more than a striking resemblance between some of the main characters and real-life personalities. Packed with sex, political intrigue, and corruption, it follows four Tyneside friends – Nicky, Mary, Tosker and Geordie – through three decades.

It has taken years of hard fighting to win Our Friends its rightful place on television after being shelved by a series of BBC executives alarmed by its stark, gritty content – and by the bill for filming such a mammoth production.

Originally written for the stage by Peter Flannery for the opening of the Royal Shakespeare Company's The Pit theatre in 1982, it was first commissioned as a four-part series by BBC *Pebble Mill.* It then went through two re-writes in 1988 and 1992 – expanding all the time to keep abreast of changing events.

What originally took about two years to write, ended up taking a total of six years over a fifteen-year period – encompassing the Thatcher years and the dawning of the possibility of a new Labour Government. Then, in March 1994, Flannery and the BBC

came to a compromise and *Our Friends in the North* was in production – at a cost of £7 million.

It couldn't have come at a better time as events in the '90s took on a parallel course with those of the early 1960s, with Labour piling the pressure on an exhausted Tory government and the news dominated by political sleaze. Getting the series to the screen became as much of a saga as the storyline. Almost immediately the series lost its designated director, Danny Boyle, who went on to direct the film *Shallow Grave*.

Casting came next, with new director Stuart Urban securing Christopher Eccleston – of *Cracker and Hearts and Minds* – as Nicky, and Malcolm McDowell in his first BBC appearance and first TV role in Britain for fifteen years.

The other main characters were then cast – with the only true north easterner in the main four being actress Gina McKee (Mary). A few weeks into shooting, Urban left and was replaced by Pedr James, who had worked on Martin Chuzzlewit, then Simon Cellan Jones.

But the team soon banded together and twelve months were spent filming throughout the north east and in London.

Videos of *Auf Wiedersehen, Pet* helped Mark Strong (Tosker) get his Geordie accent spot-on. 'I used to stick the tapes on when I was doing the hoovering. Once I'd acquired a Geordie accent it stuck. I used to be really good at accents, but I can't do anything but Geordie now.'

The only complaint Daniel Craig (Geordie) has is he didn't have enough time to sample the Newcastle nightlife to its fullest. 'According to a poll, Newcastle is ranked as the eighth most exciting place on the planet,' he said. 'That's complete rubbish. By my reckoning it's number-one.'

1996: The £15m man

Newcastle United stunned the world of football by signing Alan Shearer for a world record transfer fee in the summer of 1996.

Arriving from Blackburn Rovers for an eye-watering £15 million, the irony, of course, was that Shearer was a Geordie who'd escaped from under the Magpies' noses, and headed to Southampton as a youngster.

A talismanic figure at St James' Park, the powerful centre-forward netted a club record 148 goals in 303 appearances over ten seasons. A captain of England as well as the Toon, and the Premier League's record goalscorer, Shearer is one of the greatest players in Newcastle United history.

Evening Chronicle, Monday 29 July 1996

£15 MILLION: SHEAR JOY AS UTD NET ALAN

Newcastle United have sensationally signed Alan Shearer. The deal has cost them a staggering world record £15 million to bring the Geordie boy back home from Blackburn Rovers.

Shearer was having his medical today and will join United on their Far East tour in the next couple of days. His arrival at St James' Park will take Kevin Keegan's spending to just under £60 million.

The dramatic news will reverberate round world football.

United fans and Shearer's Geordie-based mentor Jack Hixon will be delighted. But the news will be greeted with dismay at Blackburn and Old Trafford. The news was revealed today by Keegan, club vice-chairman Freddie Shepherd and director Douglas Hall as United trained in preparation for tomorrow's game with the Thai national side.

In a joint statement they said, 'Yes, we've got the big one we wanted. We have signed Alan Shearer for £15 million in a five-year deal. He's having his medical today. We will get him over here as soon as we can.'

Keegan who had just taken part in a gruelling nine-a-side practice match added, 'This is a signing for the people of Newcastle. We are making no further statements on the matter until we hold a press conference for the people of Newcastle when we get back home.'

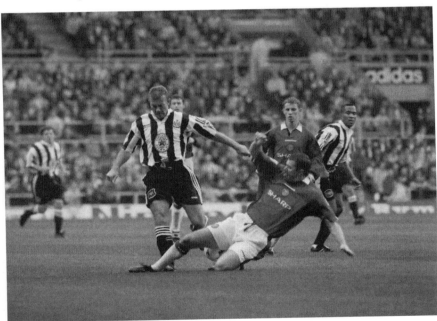

Alan Shearer, Newcastle United's new £15m signing, in action against Manchester United at St James' Park on October 20, 1996.

Russell Jones, director responsible for the ground development, chipped in: 'Perhaps people will realise now why we need a 75,000-seater stadium.'

Shearer said today, 'I was particularly impressed with Alex Ferguson, but Kevin Keegan also has great qualities and at the end of the day it was the challenge of returning home and wearing the famous black and white shirt which made up my mind for me. My four years at Blackburn have been magnificent and I personally want to thank Jack Walker for his care and consideration. He battled to persuade me to stay, but I simply felt it was time for a fresh challenge.'

Shearer has shaken off a bad knee injury and his medical will pose no problems. What might be difficult is getting the England international out to Bangkok. United leave Thailand on Wednesday morning. But it looks as though Shearer will be with them for the remainder of the tour in Singapore and Japan.

And what a welcome Shearer, Keegan and the United directors will receive when they touch down at Newcastle airport a week tonight. The signing will see United doubling their record transfer fee eclipsing the £7.5 million they paid to Parma for Tino Asprilla in February. It is £2 million more than the previous world record of the £13 million it cost AC Milan to sign Lentini.

Shearer's signing will lead to talk in some quarters that United will sell Les Ferdinand, and Arsenal are bound to test the market. But Keegan will want to play his two England men together.

In fact, Newcastle will now be able to play a £31 million strike force of Shearer, Ferdinand, Asprilla and David Ginola. Blackburn supremo Jack Walker said, 'After hours of talks I realised there was nothing we could do to keep Alan. We thought he was happy, but when we found out he wanted to leave we were shocked. The club is devastated but we still have a tremendous relationship with Alan.'

1999: Total Eclipse

To our distant ancestors, they struck terror in the heart and were harbingers of catastrophe.

Here in the twenty-first century, they're regarded as rare headline-grabbing astronomical phenomena.

We're talking about the strange happening that is a solar eclipse, when the moon – wholly or partially – covers the sun and the earth is shrouded in shadow. And so at 11.00 a.m. on August 11, 1999, the people of the *North east*, and much of Britain, momentarily stopped what they were doing and cast their (hopefully protected) eyes skyward.

The eclipse was relatively brief, but nevertheless eerie, dramatic and memorable.

Evening Chronicle, Wednesday 11 August 1999

THE DARK SIDE OF THE TOON

Thousands of skygazers gathered on north east streets today to catch a glimpse of the much hyped solar eclipse.

Offices came to a standstill as workers streamed out of buildings to view the once-in-a-lifetime phenomenon. Emergency services said phones went quiet for around twenty minutes and trials at Newcastle Crown Court were halted as judges and solicitors, but not defendants, lined up on the Quayside to view the moon covering 85 per cent of the sun. But even though weather experts said clear skies across Tyneside made it one of the best places in the country to view the eclipse, the occasion received a mixed reception.

Amer Shah, thirty-five, a refugee service worker, watched the eclipse around Grey's Monument in Newcastle city centre and said, 'It was very beautiful. The orange glow of the sun was a lovely colour.'

A solar eclipse over the Tyne Bridge, 11 August 1999.

Hundreds of people crammed into Gosforth Central Park armed with pinhole cameras and eclipse glasses to watch the skies turn dark, but barman Neil Turner, twenty-five, of Sandyford, said, 'After all the hype I was expecting something much better. It went slightly darker but no more so than a dull Tyneside day. I suppose we were lucky that the weather was good and you could see it through the glasses.'

In Cornwall, where there was a total eclipse, thick cloud meant the thousands of people who had made the journey were not able to catch a glimpse of its passing. But the countdown to the moment when daylight was submerged in darkness was met with a loud cheer and camera flashes and fireworks lit up the sky.

Paramedics in the north east reported a drop in calls from 11.00 a.m. to 11.20 a.m. but said there were no incidents involving eye damage. Northumbria Police also said there was a lull in calls to its control rooms.

More than 300 people crowded around the Angel of the North in Gateshead. Jackie Reed, forty, a housewife, said, 'The Angel is a national landmark and so close to home that we had to come down here to watch it. I thought it was very important for the kids to see something so momentous.'

David Hunt, forty-five, said, 'It was the most amazing sight. We were able to watch the whole of the sky from the hill where the Angel stands.'

Astronomer Patrick Moore, who watched the eclipse from Falmouth, said, 'It was a very eerie experience. We were under total cloud. The drop in the light and temperature was quite amazing and the rise in the end was equally remarkable.'

More than 200 people jetted out from London's Heathrow Airport on two history-making Concorde flights to chase the moon. Flying at supersonic speeds, 55,000 feet above planet Earth, there was no chance that the clouds would spoil their view of the total eclipse of the sun.

Despite employers' efforts to carry on business as usual, the Chamber of Commerce estimates that £125 million in revenue was lost across the country as a result of the eclipse.

1999: Bobby Robson Comes Home

Bobby Robson arrived at Newcastle United in September 1999, with the club in turmoil following the resignation of manager Ruud Gullit.

A respected figure in world football, the sixty-six-year-old had successfully managed England, Ipswich Town, and a host of European clubs, including Spanish giants, Barcelona.

The charismatic Robson wasted no time in turning around the fortunes of his boyhood club, leading them to the higher reaches of the Premier League and into the

Champions' League. Like Kevin Keegan, one of his predecessors as manager, Sir Bobby was seemingly at one with Newcastle United, the traditions, and the fans.

An inspirational figure, he was knighted in 2002, before leaving St James' Park in 2004. Here, John Gibson, the Newcastle *Chronicle*'s respected sports journalist and a friend of the new manager, gave his assessment of Robson's arrival on Tyneside.

Evening Chronicle, Friday, September 3, 1999

SURVIVOR WHO THRIVES ON MANAGING IN A CRISIS

Bobby Robson has come home by public demand - a father returning to sort out a household that has become unruly in his long absence.

He may be 66 years of age - his birth certificate has been scrutinised more than a highly impressive CV - but don't let the grey hair, benign appearance, and health scare fool you.

Robson insists that the pressure which sent a younger man, Ruud Gullit, scuttling back to Amsterdam won't usher him into a strait jacket or a hospital bed. Because this is the man who survived not only the long knives of Barcelona, where even a three-goal victory was questioned as not worthy enough, but a tabloid war during his eight years in charge of England's international team.

He was hounded unmercifully yet defied all to take his beloved England to the semi-finals of the 1990 World Cup and thus became the most successful England manager on foreign soil. It was his goodbye to the land of his fathers.

Robson went on to win trophies at Porto, at Barcelona, and twice at PSV Eindhoven. That he was eventually hailed as 'a national treasure' was merely part of the tabloid way of life.

One paper, having discovered that Robson was preparing to go abroad when his England contract ran out, called him a traitor and a liar. That horrendous slur brought a large out-of-court settlement.

I've known Bobby for almost thirty years and I couldn't think of two more ill-fitting words to describe him as 'traitor' and 'liar'. He is, in fact, an old-fashioned patriot. However, he doesn't hold grudges and hates to fall out with people as he did initially with Kevin Keegan after dropping him from his England squad on the arrival of KK at second division Newcastle.

Keegan took the hump but eventually they made their peace to such an extent that Bobby was invited into Kevin's new England set-up. Robson gets hurt, of course, like any human being, but prefers to remember the good times a great game has given him since he left Langley Park as a wide-eyed youngster to take to soccer's yellow brick road.

Robson's strength, initially nurtured during his hugely successful thirteen years as the miracle worker of Ipswich Town, is man-management. He knows how to handle stars – didn't he prove it with the temperamental Ronaldo at both PSV and Barcelona?

Bobby will listen to players' opinions, rather than adopt the cold and aloof approach of Gullit, and give them careful consideration. But the buck still stops with him.

An aerial shot of Newcastle city centre including the Centre for Life, in the middle of the picture, which was opened in May 2000.

He loves working with players, he prefers a track suit to a lounge suit. When I flew to Portugal to spend three days with him, all he wanted to do was get out on the training ground with his players – the idea of age confining him to a quiet room with a telephone was abhorrent to him.

Indeed the Continental system, whereby players' contracts and transfer negotiations were handled by the club president, delighted him. It left him free to do what he feels he does best.

I arrived safely in Oporto but my luggage didn't, and I spent my whole time out there wearing Bobby's blazer emblazoned with club badge. He picked me up from the airport, took me training, and arranged dinner in the best of restaurants. I was, after all, a fellow Geordie – one of his own.

Wherever we went he was hailed as 'Mister', their sign of respect for a coach who won them more than admiring glances. His love of his roots has never left him, just as it never left Bob Paisley. He was always willing to come back and we worked together incessantly on the talk-in circuit throughout the north east. He'd never played nor managed here but Newcastle United was never far from his lips. Now, belatedly, he's returned for a final hurrah.

I know that some friends who love him and want to protect his reputation have urged him not to risk all at a club where the rewards are high but so too are the pressures and expectations.

They point to another Geordie, Lawrie McMenemy, who had a magnificent track record at Southampton but couldn't resist the temptation to do it on his own patch and consequently will forever be remembered for his failure at Sunderland. But then a man who lacked courage would never have gone to a club like Barcelona in his sixties, would he?

Many may live in happy anticipation of retirement, but to a footballing man like Robson it's akin to a prison sentence. Long hours with little of interest to do.

Welcome to the pressure cooker, Robert!

2000: New Year

It's not often we get the chance to welcome in a new century, let alone a new millennium.

But as the twentieth century drew to a close, the people of Newcastle were in the mood 'to party like it's 1999', as the song goes!

Thousands of Geordies, like countless millions around the planet, celebrated the arrival of the 2000s.

Organised events at Newcastle's Haymarket and on the Quayside saw families and revellers welcome in the new age. The climax of the night saw the Tyne Bridge engulfed in a stunning conflagration of fireworks.

The 1900s were gone. What would the 2000s bring?

The Journal, Saturday 1 January 2000

36,000 JOIN IN THE CITY'S CELEBRATION
Magical Mix in the Quayside Jamboree

Some 36,000 people packed on to Newcastle's Quayside to revel in a millennium spectacle to remember.

Engulfed in a mystical green glow from the Tyne Bridge, the year 2000 arrived in style in the north east's 'capital' city. Live music complemented street theatre and regular processions along the River Tyne in a larger-than-life extravaganza that catered for the whole family.

The two stages on the Quayside drew packed crowds throughout the night, with traditional Geordie favourites Lindisfarne attracting huge cheers for their hour-long set. The classic act was followed by the appearance of 50 foot Latin American puppet dancing partners making their way down on to the Quay in time to the rhythmic music and the delighted gasps of onlookers.

Everywhere there were queues a mile long as people waited patiently to get into one of the many packed bars and restaurants lining the Quay. Swirling in a magical mix of fancy dress, silly hats and fluorescent headbands, the Quayside was alive with laughter and music from the very start of the evening right through into the first hours of the new millennium. Street crowds revelled in the sight of 12 foot skeletons parading on the pavement and firecracker-wielding futuristic figures on stilts making up a spectacular procession.

An incredible firework display capped a truly memorable evening of entertainment to match celebrations anywhere else in the country.

Seconds before midnight on the Quayside, Newcastle schoolgirl Harriet Baker, fifteen, wrote her name into the history books when she read out a special millennium message with the last words to be spoken on the BBC – other than those of David Dimbleby – before the old century died.

Under a waterfall of silver stars cascading off the north east's most distinctive piece of architecture, the Tyne Bridge, the 36,000 revellers welcomed in the New Year. From 11.00 p.m., the anticipation had started to build among the crowd and with just fifteen minutes to go before midnight the atmosphere was electric.

On the first stroke of the new millennium, the sky burst into colour and thousands of fireworks rocketed into the air. With the final explosion of light, a huge cheer went up from the crowd and the heaving mass of people turned in.

Meanwhile, if the Quayside was where Newcastle's 'in crowd' went to party, the Haymarket was the place for families. Here, amid the drizzle and the smell of hotdogs, around 20,000 of all ages gathered for a spectacular fireworks display to welcome in the year 2000.

They may have needed a wristband for the more exclusive Quayside bash, but at least at the Haymarket there was space to dance. Many had already left by 6.30 p.m. but even by then they had seen such a show that the beginning of 2000 would always be remembered with a certain sense of wonder.

It takes a lot to get tens of thousands of Geordies to burst into spontaneous applause, but a string quartet suspended 50 feet above the Civic Centre gardens, accompanied by a troupe of sadly-earthbound drummers, certainly does the trick.

Huge screens either side of the main stage broadcast Newcastle schoolgirl Harriet Baker reading the Millennium Prayer on television, and fireworks launched from behind the Civic Centre underscored the message.

Welcome to the 2000s!

2000: Centre for Life

Built on the site of Newcastle's old Marlborough Crescent bus station and livestock market, the Centre for Life was opened by the Queen in 2000.

Nearly 600 people work in the science village which is funded by charity. Scientists, clinicians, educationists and business people work to promote the advancement of the life sciences.

The complex also host the Life Science Centre which features a number of temporary and permanent exhibitions, a science theatre, a planetarium and a 4D Motion Ride, as well as presenting science-themed special events for children and adults.

The Life Science Centre also has an educational programme providing science workshops to schools and other groups.

Evening Chronicle, Tuesday 23 May 2000

CHECK OUT THE WONDERS OF LIFE
£25 Million Tyneside Centre Will Take Visitors on a Journey Through the Human Body

Chronicle readers are treated to a sneak preview today of Tyneside's own Millennium spectacular.

The new £25 million family visitor attraction will open its doors officially for the first time on Saturday. Some Millennium projects have failed and the London Dome is at the centre of new controversy over spiralling costs. But bosses are confident the Tyneside venture will pull in the crowds and they invited the *Chronicle* to an advance showing of the entertainment inside.

Life Interactive World in Newcastle uses the latest advances in entertainment technology to teach the secrets of life. It employs hands-on, state-of-the-art technology and an impressive combination of audio-visual wizardry with live interactive characters to explain some of the principles which underpin life itself.

From the world's first 3D film showing a baby developing from embryo to birth, to a virtual games arcade and the world's longest continual motion simulator ride, the latest

An aerial shot of Newcastle city centre including the Centre for Life, in the middle of the picture, which was opened in May 2000.

technology is used to bring life alive. The experience takes visitors on a unique journey through many different aspects of life, looking at evolution and DNA, the way a human brain works and the way a baby develops inside the womb. Life is seen through the eyes of a man rushing to be present at the birth of his child.

The attraction, part of the £70 million International Centre for Life complex in the west of the city, has been split into nine zones which explore different stages of life from the single cell. They also examine the working of the brain and the senses.

Linda Conlon, director of Life Interactive World, said, 'There is nothing quite like this in the north east and we think we have it right.'

The centre houses the Crazy Motion Ride, which is Newcastle's answer to Alton Towers. It is the world's longest continual motion film, offering white knuckle thrills as life is depicted as a rollercoaster.

Bosses at Life Interactive World hope to attract 200,000 visitors a year and have written to more than 6,000 schools across the region inviting them to take part.

2001: The Blinking Eye Bridge

The Millennium Bridge, which links Newcastle and Gateshead Quaysides, is one of the region's most celebrated modern landmarks. The award-winning structure was designed by architects Wilkinson Eyre and structural engineers Gifford.

The bridge, along with the later Baltic modern art gallery and Sage music centre on the south bank of the Tyne, has perhaps come to symbolise the rise of post-industrial Tyneside.

It was lifted into place in one piece by Asian Hercules II, one of the world's largest floating cranes, on 20 November 2000.

The bridge was opened to the public on 17 September 2001, and was dedicated by Queen Elizabeth II on 7 May 2002. It cost £22 million to build.

The Journal: 18 September 2001

EYE-CATCHING DESIGN CREATES HISTORY

The creation and opening of Tyneside's Millennium Bridge was a piece of history in the making.

Nicknamed the 'blinking eye' – as its unique design allows ships to pass underneath by mirroring the workings of a human eye – the £22 million project is the first opening bridge to be built across the River Tyne for over 100 years.

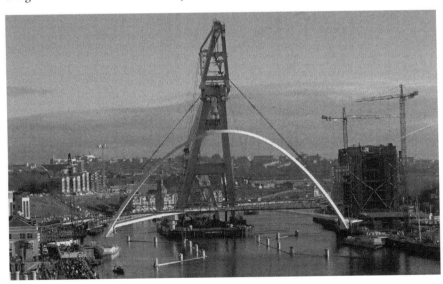

The Asian Hercules floating crane lowers the Millennium Bridge into place on the Newcastle-Gateshead Quayside, 20 November 2000.

Funded with the support of a £9.7 million grant from the Lottery Commission, as well as support from regional development agency One NorthEast and the European Community's Regional Development Fund, the bridge has attracted international attention since the design was unveiled.

Interest has been so great that the website which shows pictures of it bridging the Tyne, as well as details of its design, has attracted more than one million hits and requests for information and pictures have flooded in from across the globe.

'The idea for a bridge came almost five years ago after we had decided to create the gallery at the Baltic Flour Mill,' explained Gateshead Council spokesman Robert Schopen. 'We needed to open that part of the Gateshead Quayside so that people could cross the river at that point by foot. When we mentioned it to our colleagues in Newcastle they agreed. It was decided that the best way to come up with a design was to hold a competition for people and firms to send in their designs and then through public consultation we would pick the most appropriate.

'We had more than 150 entries and narrowed them down to a shortlist of six. This was the most impressive and the one we felt symbolised the change of Gateshead and Tyneside into a leading cultural centre. The design was the unanimous choice of the judges and won overwhelming support from the public who saw the shortlisted entries during exhibitions across Gateshead and Newcastle.

'Almost half opted for the winning design – three times as many as its nearest rival.'

But the bridge itself was not the only spectacle to be seen on the Tyne in the last year. The 350ft crane, Asian Hercules II, used to carry the bridge down the Tyne and to place it in its new home, was a magnificent site. With a deck the size of a football pitch, the titanic crane became one of the most identifiable landmarks on Tyneside as it waited in November for the perfect weather conditions to carry out its task.

When the wind finally died down enough for the bridge to be carried the six miles from its construction home in Wallsend to its current site, thousands lined the banks of the Tyne to see it being lowered into place. And it was not just the north east that watched in amazement.

A television audience of millions witnessed the spectacle in Australia, Canada, Germany, Holland, Norway, Spain, Japan and across Britain.

2001: Spoon Barmy

In 2001, for a bit of fun, the *Evening Chronicle* approached TV psychic Uri Geller to help end Newcastle United's barren run of results in London.

Born in Israel in 1946, Geller had shot to fame in Britain in the 1970s. He stunned television audiences with his ability to bend, break and soften metal and other solids,

most notably household cutlery such as spoons using, so he claimed, the power of his mind.

In the event, Geller's intervention saw the Magpies beat mighty Arsenal 3–1 at Highbury. Under the page one headline 'Uri-ka', the *Chronicle* published one of its most bizarre stories.

Evening Chronicle, Wednesday 19 December 2001

ARSENAL 1 'SPOON ARMY' 3
Psychic Uri to the Rescue as Gunners are Shot Down by Attack of the Bends

Psychic Uri Geller was a Toon hero today after helping the *Chronicle* banish Newcastle United's London curse in staggering style.

In an incredible match, the Magpies soared to the top of the premiership after finally ending their run of twenty-nine matches without a win in the capital. As Bobby Robson's heroes began their fight back in the 3–1 thriller, world-famous paranormalist, Uri, was running around the London stadium a magic eleven times willing United on to victory.

Uri claimed eleven, the sum of the two and nine in twenty-nine, was Newcastle's magic number and he was proved right in spectacular style.

Today even shell-shocked Arsenal boss Arsene Wenger admitted he felt like 'there was a sorcerer at work' on the pitch last night.

Uri, who succeeded where exorcists and voodoo witchdoctors had failed before him, said, 'I put my heart into this. This is incredible. I knew the team would win. I am so happy for everyone who supports them. It was exactly what I said.'

Newcastle's first win in London since November 1997 came during an amazing match with two sendings off, a penalty and outrageous after-match scenes as Arsenal striker Thierry Henry went mad at the referee.

For thirty minutes it looked like Newcastle could be heading for match number thirty without a win after the Magpies went one down to a goal from Thierry Henry. But Uri had his own explanation as to why the first half had been so torrid, he was late for the match. He said, 'I arrived late and had no ticket. But the moment I got out of the car and touched the Highbury stadium, the Arsenal player Ray Parlour was sent off. When we approached I had the scarf, the football and the shirt and I have the feeling Newcastle people are open minded and that they would go along with my instructions to look at the picture in the *Chronicle* of me. They are not cynical.

'I started screaming and shouting for Newcastle to win. And soon after the start of the second half I said to my friend that Shearer would score from a penalty. That was half an hour before it happened. But I knew it. I knew the team would win. I am so happy for everyone who supports them. It was exactly what I said. While Newcastle were scoring their winning goals I was running round the outside of the ground eleven times to lift the hoodoo.'

Yesterday we revealed how Uri had vowed to break the curse after the *Chronicle* called on his aid following two failed attempts to lift the Toon's capital curse. We were determined to lift the hoodoo and had already called on exorcists and two voodoo witch doctors.

Finally, and in desperation, we saw the light and finally called in psychic Uri who rocketed to fame in the 1970s using his amazing mind power to bend spoons and stop watches worldwide. He promised us that with his positive thinking he could make the likes of Shearer bend the ball like he bends spoons.

The fifty-four-year-old said, 'I even predicted the 3–1 scoreline after I got to the ground. We are all connected to each other and with this individual spiritual thread we can transmit energy. Your readers were so powerfully determined that there was no doubt Newcastle would win.'

2005: Tall Ships Race

The fabulous Tall Ships Race first graced the River Tyne in 1986 when Her Majesty the Queen paid a visit to the Quayside, then again in 1993, before returning once more in 2005.

On that occasion, the cost of hosting the event was £1.5 million, but an estimated £50 million was generated for the local economy.

The Tall Ships Race has run annually in European waters since 1956, consisting of two races over hundreds of nautical miles. The spectacular event aims to foster understanding and friendly rivalry between young folk from around the world, and help instil teamwork and determination, as well as giving them seafaring skills.

Sunday Sun, 24 July 2005

ON THE CREST OF A WAVE

Hosting the Tall Ships event will be plain sailing for organisers this year as the brilliant boats have already weighed anchor on Tyneside twice before. Yet visitors to the previous events in 1986 and again in 1993 will notice big changes this time around.

It's always a spectacular sight – the Tyne filled with majestic sailing vessels –but 2005 promises to be even more special because for the first time the ships will be berthed along both sides of the river, instead of just on the Newcastle banks.

'Visually, to have ships on both sides for the first time will be really impressive,' says Phil Payne, the man charged with running the Tall Ships. 'This is something that came out of the European Capital of Culture bid where Newcastle and Gateshead began working much more closely together to make it a jointly organised event.'

And it will bring into sharp focus the vast amount of regeneration that has gone on over almost two decades on both banks of the river.

A spectacular shot of the Tall Ships on the River Tyne in July 2005.

In 1983 the regeneration had hardly started. Yet even since the last event in 1993, amazing new landmarks have risen from the ashes of the Tyne's industrial past.

The Sage Gateshead music centre, Baltic and Millennium Bridge will of course be centre stage when the crews come to call. Those crews will also have a more international flavour. There'll be ships from as far as Indonesia, India and Oman as well as from countries that have visited before like Russia and North and South America.

Although there were more vessels involved last time around, 122 compared to this year's 105, there will be more of the big 'crowd pullers' as Phil describes them.

He says, 'We certainly have more Class A vessels this year – twenty-eight in all, which is a record – so while the numbers are slightly down, in terms of the big impressive ships we have more this time.'

Organisers are also hoping the event will raise a lot more cash for the local economy than in previous years. In 1993 it was boosted by an estimated £38 million. In 2005 predictions are that there'll be an additional £50 million of expenditure throughout the region.

Phil says, 'In terms of visitor numbers the Tall Ships will be the largest free event in the UK this year. There will be 3,000 to 4,000 youngsters participating and around one million visitors over the four days. The rules of the race say half of each crew has to be between sixteen and twenty-five years old, and they will come from over twenty countries.' Organised by Sail Training International, the event will see four days of activities, with racing between ports.

The ships will arrive on the Tyne having sailed from Cherbourg in France, and will travel on to Fredrikstad in Norway after their time here in the North.

2006: A TV Legend Retires

It was the end of an era when television news favourite Mike Neville called it a day back in 2006.

For folk in the region, he'd been the friendly, familiar face of local TV for four decades.

A superb newsman and polished performer, he was also a master of the ad lib and of dealing with any technical mishap with humour and aplomb.

At the time of his retirement, the *Evening Chronicle* declared, 'Mike Neville is a legend – the face of north east television news for more than forty years. He has no equals. Generations have grown up with Mike, whether it be BBC Look North or Tyne Tees. We wish him well.'

The Journal, Tuesday 6 June 2006

MIKE NEVILLE SAYS GOODNIGHT – FOR NOW

Popular news broadcaster Mike Neville welcomes young visitors to Newcastle's BBC studios in October 1980.

TV presenter Mike Neville has announced the end of his forty-year daily television career after admitting defeat in his battle against illness.

The region's best known broadcaster is to step down from the Tyne Tees news programme *North East Tonight*, though he still hopes to work in TV occasionally.

His announcement marks the end of a career stretching back to the 1960s, which included a long spell at the BBC and occasional forays into national television. Figures in the regional and national broadcasting world last night paid tribute to Mr Neville, who has been off work since lifesaving emergency surgery to remove a blood clot last July.

He had originally hoped to return to his job as the daily news presenter but has now admitted that that won't happen.

Tyne Tees bosses have begun the search for his successor, though in the short term they will continue with a rolling team of presenters on their nightly news programme. Mr Neville said yesterday, 'I've been thrilled at the number of letters and cards I've received from viewers over the past months whilst I've been recuperating. I am going to miss being invited into their homes every evening at six o'clock. But as one chapter ends, another begins. I'm keeping the door open with ITV and I'm working on other projects. I'm not quite ready for retirement.'

The first British TV presenter to rack up forty years in daily broadcasting, Mr Neville is best known as the long-serving host of *BBC Look North*. He was a regular presenter of the national show *Nationwide* in the 1970s, but resisted offers to move to London full-time to remain in his native north east.

His career saw him pick up a number of broadcasting awards, as well as an MBE in 1990 for services to television and an honorary degree from Northumbria University. Friend and ITN newsreader Nicholas Owen – who had Mr Neville as his best man – yesterday led the tributes to him.

He said, 'We're not going to see his like again. When Mike Neville walked into Gateshead Register office to be my best man, the registrar was so lost for words that I sometimes wonder if I'm actually married. I learned almost every aspect of this job that I do from Mike Neville. He was simply very good at what he does.'

Former BBC colleague Chris Jackson – who was one of the presenters who took over from Mr Neville when he went to Tyne Tees in 1996 – said, 'He sent us a good luck card when we took over. He didn't have to do that because he was joining the opposition, but he wished us well and that was a sign of the man.'

One north east chairman Margaret Fay, who was Tyne Tees managing director when Mr Neville returned to the channel, said, 'I worked with Mike for many years, and have fond memories of that time.'

Mr Neville, sixty-nine, lives in Whickham, Gateshead, with his wife Pam. They have a daughter and four grandchildren. An advert for Mr Neville's replacement will be put out soon, although it is likely that *North East Tonight* will switch to have two regular presenters.

2009: Farewell to a Legend

Sir Bobby Robson will be remembered as one of the north east's favourite sons. He fought cancer five times before it finally claimed his life on 31 July 2009.

His death sparked genuine outpourings of grief and affection across the region, and beyond.

As a football man, he will be remembered as one of England's greatest. But perhaps his finest tangible legacy is the Sir Bobby Robson Foundation, a cancer research charity set up in 2008. Five years after his death it had raised £7.5 million.

Sir Bobby's last public appearance was at a football match, in aid of his charity, at St James' Park. He passed away peacefully just a few days later.

Evening Chronicle, Thursday 31 July 2009

THE GREATEST MOVING TRIBUTES TO GRAND GENTLEMAN OF FOOTBALL: SIR BOBBY ROBSON

From princes to paupers and politicians to soccer stars, they've all been touched by his greatness.

People from all walks of life and all corners of the globe today paid tribute to Sir Bobby Robson. The seventy-six year old passed away in his Durham home yesterday after battling cancer for the fifth time.

Tributes to the former Newcastle United and England manager were led by Alan Shearer, who told the *Chronicle*: 'My memories of Sir Bobby will live with me forever.'

Former Newcastle United midfielder Rob Lee, who played under Sir Bobby for three seasons, said, 'Sir Bobby's death will devastate a lot of people. I have admired Sir Bobby since the World Cup in 1990 for the way he carried himself as a manager and a gentleman and how he inspired others. It was incredible to work with him on the training pitch because he lived football. But he was first and foremost a great man. A gentleman.'

Sir Bobby was born the son of a County Durham miner, who rose from humble beginnings to become a hero.

His first taste of football was in the streets where he played with his four brothers. He went on to sign for Fulham, where he made 152 appearances, scoring sixty-eight goals, before joining West Brom, then re-signing for the Londoners.

He also starred for England in the 1958 World Cup in Sweden, going on to win twenty caps. As a manager, he won the FA Cup and UEFA Cup with Ipswich Town, before becoming England manager, where he most famously took the Three Lions to the World Cup semi-final in 1990, narrowly losing to West Germany on penalties. He also managed Barcelona, PSV Eindhoven, Porto and Sporting Lisbon, before being brought

to Newcastle United in 1999. Off the pitch, he battled cancer five times, the disease which would eventually claim his life.

After leaving the game, Sir Bobby turned his attentions to raising cash for his charity the Sir Bobby Robson Foundation and it was for that cause he staged a re-run of the Italia '90 semi-final at St James's Park on Sunday.

That England vs Germany re-run would be the last game he would take in before passing away. Former striker Gary Lineker said, 'I was deeply saddened to hear of Bobby Robson's death. He was a great football man. He had a tremendous enthusiasm and passion for football and life, and continued to retain this right to the last days of his life.'

Paul Gascoigne, who famously cried after England were knocked out of the World Cup in 1990, said, 'He was like a dad to me. I'll never forget the love he showed me. Sir Bobby is a legend all over the world.'

Ex-Toon star Lee Clark said, 'It's a very sad day for football and a very sad day for the country because he was respected in all walks of life throughout the nation.' Newcastle Central MP Jim Cousins said, 'When I heard the news, I was actually in the Freeman Hospital, here in Newcastle. What was extremely moving to me was the very profound reaction of everybody there, men and women.'

Lord Mayor, Cull Mike Cookson said, 'I had the pleasure of being in his company on Sunday at his charity match and was overawed by his resilience and dignity. He was the north east's foremost ambassador who never missed an opportunity to promote the region and his beloved Newcastle United which he took to new heights in Europe.'

Professor Ruth Plummer, the director of the Sir Bobby Robson Cancer Trials Research Centre, said, 'He knew we were moving to a new centre, and I explained to him that we were trying to raise money. In true Sir Bobby style, within six weeks he had set up a charity and seven weeks later he had raised more than half a million pounds.'

2012: Survivor

Over two and a half decades after her life-saving heart transplant, Kaylee Davidson is a living testament to the skill of surgeons at Newcastle's Freeman Hospital.

Today she lives life to the full. Notably, she won a gold medal at 2013's World Transplant Games in Durban, South Africa for her part in the 4x100m relay.

Today, the Freeman carries out around eighty transplants a year, the largest programme of its kind in the UK. It's also one of only two national centres for children's transplant surgery and accepts patients from across Britain and Northern Ireland.

In the years following Kaylee's successful transplant, around 150 other children have also received new hearts.

Evening Chronicle, Saturday 13 October 2012

25 YEARS OF MIRACLES AND MAGIC AT NEWCASTLE'S FREEMAN HEART UNIT

Heart transplant first Kaylee Davidson-Olley celebrated a quarter of a century since her pioneering operation.

Kaylee made medical history when she became the first baby to survive a heart transplant twenty-five years ago.

Diagnosed with cardiomyopathy, she was seriously ill in intensive care for six weeks before the operation at Newcastle's Freeman Hospital. To mark the momentous occasion, the sales adviser met with thirty other heart transplant patients and medical experts at the Centre for Life yesterday.

Kaylee, of Houghton-le-Spring, Tyne and Wear, said, 'I cannot believe that I am fit and healthy twenty-five years after my heart transplant. This was only made possible because of the generosity of a family who made that important decision about organ donation, a decision that saved my life. It is overwhelming to see all the people who have had their lives saved by a heart transplant.'

Since Kaylee's successful heart op on 14 October 1987, the Freeman Hospital has become a Centre of Excellence for paediatric heart transplantation.

Kaylee's mum Carol Olley, forty-four, a children's welfare consultant, said, 'It is really emotional to think that twenty-five years ago Kaylee was given the operation and the gift of life. When she was given the heart transplant no one knew what would happen and it was a leap of faith by the medical staff. It is amazing how well Kaylee is doing and the quality of life that she has. We are so proud of her. She is an amazing and inspirational young woman.'

Kaylee has spent her life campaigning to encourage more people to go on the organ donor register. She lives a full life and has been picked for Team GB for the World Transplant Games in Durban, South Africa, next year.

In total, 112 babies under the age of one year old have received new hearts during the past twenty-five years in the UK. Sadly, sixty-one babies have died whilst waiting for a transplant due to the shortage of donor organs.

Two children have already died this year whilst waiting for organs, and this week alone there are six babies in the UK desperately waiting for a new heart.

2015: The 'New Castle' is Reborn

Forget the Tyne Bridge, and certainly those north east new kids on the block, the *Angel of the North* and the Millennium Bridge.

The region's most enduring and powerful symbol is, surely, Newcastle's Castle Keep. It has stood proudly through the ages, watching over the silent River Tyne, and defying the onslaught of time, the weather, invading Scottish armies, two World Wars, and threats to demolish it to make way for the railways.

In 2015, the Castle Keep and its sibling neighbour, the Black Gate, were given a major makeover. The 'New Castle' is beginning a new lease of life.

Evening Chronicle, Saturday 21 March 2015

NEWCASTLE CASTLE KEEP AND BLACK GATE REVAMP IS COMPLETE

A classic shot of the Black Gate and Castle Keep from April 1965. Both were given a new lease of life in 2015.

Newcastle's historic core opens its doors to the public as the city's latest visitor attraction. More than 160 years ago that symbol of the then-modern age, the railway, sliced between the Castle Keep and its outer gateway the Black Gate, just missing both.

The keep had survived the demolition of surrounding areas in the frenzy of railway building and the Black Gate, thanks to public pressure, would later dodge calls for it to be flattened.

But today, both the keep and the Black Gate complete their comeback when they open their doors to the public after a £1.67 million revamp project. Newcastle Castle is now the new name for the Castle Keep and the Black Gate, which occupy the site where the city was born.

The buildings, together with the adjacent St Nicholas' Cathedral, are now the heritage focus and gateway to Newcastle's story. The stone Keep dates from the twelfth Century, having replaced a Norman wooden castle of 1080, and sits on top of the Roman fort of Pons Aelius and an Anglo-Saxon cemetery. The Black Gate goes back to the thirteenth century.

The Old Newcastle Project, which has put the keep and Black Gate back at centre stage, is the brainchild of the Heart of the City Partnership, a company formed by St Nicholas' Cathedral, the Society of Antiquaries of Newcastle-upon-Tyne and Newcastle City Council.

At a re-opening launch event at the keep, Ian Ayris, head of the city council's urban design and conservation team, said, 'For the first time in hundreds of years, the Castle Keep and the Black Gate are back together.'

The keep was previously managed by the Society of Antiquaries, which also used the Black Gate as its headquarters. Society president Derek Cutts said, 'I feel like the father of the bride who, after looking after her for years, hands her over to someone else to begin a new life.'

Chris Dalliston, Dean of Newcastle and chairman of the Heart of the City Partnership, said, 'This whole historic district, which has been under-celebrated and under-recognised, has now come together. We realised that we could do something very exciting and important and now ten years after the concept began I am delighted with what has been achieved on the spot where the story of Newcastle began.'

The Heritage Lottery Fund sank £1.4 million into the project and its regional head, Ivor Crowther, said, 'People are proud of Newcastle and this project has given them a new sense of pride.'

Broadcaster and historian John Grundy said, 'The keep is an amazing, complicated and dramatic structure, and it has survived. With the Black Gate we have two fantastic buildings, with trains in the middle. It's incredible. Terrible things have happened to both buildings but now they have been revitalized to tell their stories. The city has looped around this area for too long, but I have a vision that no child should grow up in Newcastle without being brought here as part of their birth right.'

Acknowledgements

With many thanks to the following: Maria for her invaluable help and support in putting this book together. *Chronicle* Editor Darren Thwaites and staff – past and present – of the *Newcastle Chronicle*, *Journal* and *Sunday Sun*. Also, thanks for help in the 'day job' to Ray Marshall, Ann Dixon, Paul Perry, Norman Dunn, Andrew Clark, John Dawson, Charlie Steel – and to Ken Hutchinson for 'the recommendation'. And finally, last but not least, special thanks to my mother, Moira, and late father, Stan, for sparking my interest in all things historical.

'It's something I will never forget. To think I have so many
friends here in South Shields.' MUHAMMAD ALI

MUHAMMAD
ALI TYNESIDE 1977

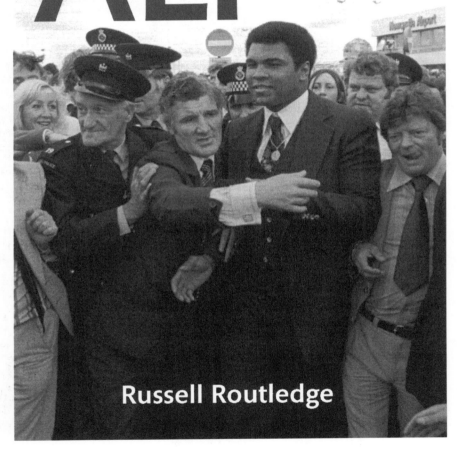

Russell Routledge

Available from all good retailers

ISBN 978 1 4456 2106 7
eISBN 978 1 4456 2112 8

Available from all good retailers

ISBN 978 1 4556 4127 0
eISBN 978 1 4456 4139 3

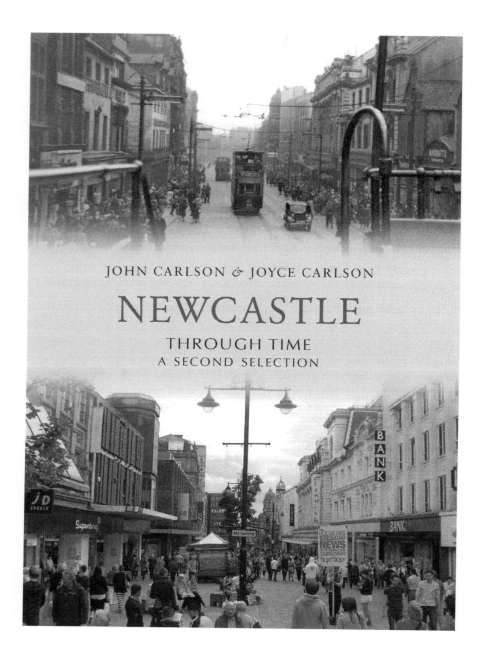

JOHN CARLSON & JOYCE CARLSON

NEWCASTLE

THROUGH TIME
A SECOND SELECTION

Available from all good retailers

ISBN 978 1 84868 178 1